IMAGES
of America

LIGHTHOUSES OF
THE BAY AREA

D1572250

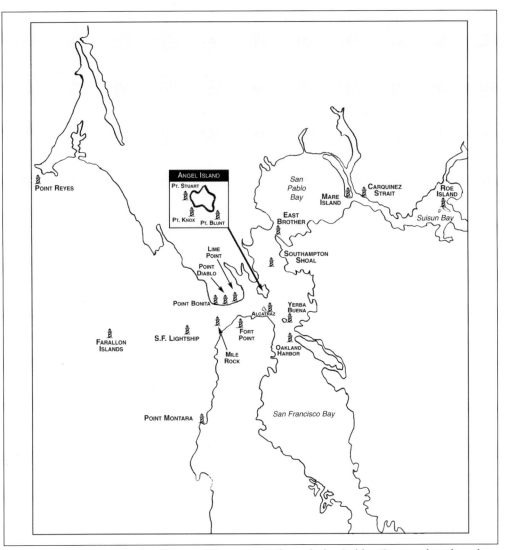

Lighthouses leading to the San Francisco Bay, passing through the Golden Gate, and guiding ships past the islands and through straits have saved countless lives. This map will provide a layout of each location as you take this photographic journey of the 19 lighthouses and ships throughout the San Francisco Bay. (Author's collection.)

ON THE COVER: Within this view of the approach to the Golden Gate, the locations of five lighthouses can be seen. Situated just one mile from the main shipping channel to the San Francisco Bay and only 704 yards off the shore of San Francisco is Mile Rock Lighthouse. Once a beautiful beacon, today the top has been removed and the platform serves as a helicopter landing pad to enable the U.S. Coast Guard to perform maintenance on the automated light. Under the south tower of the Golden Gate Bridge, Fort Point can be seen with the now deserted lighthouse still sitting on top. At the base of the north tower of the bridge is Lime Point Lighthouse, and to the left of Mile Rock Lighthouse and across the channel sits the Point Diablo light. Under the bridge, Angel Island can be seen. The island was home to three of the bay's lighthouses. (San Francisco Public Library.)

IMAGES
of America

LIGHTHOUSES OF
THE BAY AREA

Betty S. Veronico

ARCADIA
PUBLISHING

Published by Arcadia Publishing
Charleston SC, Chicago IL, Portsmouth NH, San Francisco CA

Printed in the United States of America

Library of Congress Catalog Card Number: 2008922705

For all general information contact Arcadia Publishing at:
Telephone 843-853-2070
Fax 843-853-0044
E-mail sales@arcadiapublishing.com
For customer service and orders:
Toll-Free 1-888-313-2665

Visit us on the Internet at www.arcadiapublishing.com

For my sons, David and Bobby

CONTENTS

ACKNOWLEDGMENTS

I would like to thank the people that opened their businesses and personal collections to me. Their photographs and memories make up this visual history of the lighthouses of the Bay Area. I am indebted to David, Rachel, Dominique, Sheridan, Dante, and Cheyenne Anderson; Robert Anderson; Kraig Anderson, LighthouseFriends.com; Donald Bastin, executive director of the Richmond Museum of History; Ray and Caroline Bingham; Joe and Claire Bradshaw; Rich and Arlene Bradshaw; John and Lisa Gaffney; Jeffrey Gales, Richard Gales, and Chad Kaiser, United States Lighthouse Society; Jim Kern, Vallejo Naval and Historical Museum; Vicki Larkavich, Point Montara Lighthouse Hostel; Reg and Janet McGovern; Jo Anne Montoya; Christina Moretta, San Francisco Public Library; Dr. David Rosen, U.S. Coast Guard; Joe Sanchez, National Archives and Records Administration–Pacific Region (San Francisco); Elan, Katy, and Drake Stewart and Roger Klosel, East Brother Lighthouse; Armand and Karen Veronico; Richard Wheeler; and Amanda Williford, Golden Gate National Recreational Area, Park Archives. I would also like to thank my husband, Nick Veronico; without his help and encouragement this book would never have been possible.

—Betty S. Veronico
San Carlos, California

INTRODUCTION

Lighthouses have been enchanting people since the first beam lit the night sky. The first known lighthouse was the 450-foot-tall Pharos of Alexandria in Egypt, built between 300 and 280 B.C. It was constructed by Ptolemy I and II, a father and son; was the tallest building on earth for many centuries; and was considered one of the Seven Wonders of the Ancient World. The lighthouse was slowly destroyed over the years by invaders and earthquakes, with its final demolition in the 1300s. La Coruna, Spain, houses what is believed to be the oldest existing lighthouse in the world. It is known as the "Tower of Hercules," built in 20 B.C. and standing 185 feet tall.

The first lighthouse in America was built in 1716 on Little Brewster Island, Boston, Massachusetts. The original tower was destroyed by the British in 1718, but a new lighthouse was constructed in 1784. The oldest, existing, operational lighthouse in America was completed in 1764 and is located at Sandy Hook, New Jersey. When America became a nation in 1776, there were 12 lighthouses along the East Coast.

The 1848 discovery of gold in the hills of California saw prospectors leaving their East Coast homes and heading west, many by land but most by sea. However, with the rugged coast of California and the dangers of the San Francisco Bay waters, many of the ships, their cargo, and their passengers were lost. The loss of these ships and the ever-increasing number of vessels converging in the San Francisco Bay made it evident that navigational aids were desperately needed. But the West Coast of the United States had not yet been explored, much less charted. That same year, the U.S. Congress tasked the U.S. Coast Survey, later to become the U.S. Coast and Geodetic Survey, to survey the entire 1,300 miles of the Pacific Coast from Canada to Mexico to determine the best locations for lighthouses.

By 1852, the survey was complete, and Congress authorized funds for the first group of eight lights and then almost immediately authorized an additional eight lighthouses in California, Oregon, and Washington. Funding for all 16 lighthouses totaled $148,000. Locations for the lights were Alcatraz Island, Fort Point, Point Bonita, Point Piños, the Farallon Islands, Point Loma, Santa Barbara, Point Conception, Humboldt Harbor, and Crescent City, all in California; at the entrance of Umpqua River and at Cape Disappointment in Oregon; and Cape Flattery, New Dungeness, Smith Island, and Willapa Bay in Washington.

The lighthouse construction contract was awarded to the firm of Francis Gibbons and Francis Kelly. Kelly was familiar with lighthouse construction because he was the engineer for the Bodie Island Lighthouse in North Carolina. The firm loaded the ship *Oriole* with supplies and headed around Cape Horn to begin the project. Alcatraz Island was chosen as the location for the first lighthouse. Gibbons and Kelly decided it would be more efficient to build the lighthouses in stages instead of completing them one at a time. When the foundation at Alcatraz was complete, part of the crew was moved to Fort Point to start the foundation there, and then moved to the next location, and so on. This continued until four lighthouses were complete. However, in August 1853, disaster struck. While traveling from San Francisco Bay to the Columbia River to start the lighthouse at Cape Disappointment, the *Oriole* struck a shoal near the entrance to the river

and sank. All of the construction material was lost, but the crew was safely rescued. Within several months, and at considerable cost, Gibbons and Kelly were able to secure another vessel, load it with material, and continue the project. By August 1854, the original eight lighthouses were complete.

Another financial disaster hit Gibbons and Kelly when it was discovered that many of the Fresnel lenses arriving from Paris, France, were too large for the lantern rooms. A number of the lantern rooms, as well as the entire structures at Farallon Island and Point Conception, had to be torn down and rebuilt. Any thought Gibson and Kelly had of making a profit on the lighthouse projects was dashed. The contracts for the last eight of the original 16 lighthouses were awarded to other contractors and were completed by 1858.

Lighthouses were manned by a head keeper and as many as six assistant keepers. Most of the keepers lived full time at the lighthouses, many with their families. Despite the hard work, treacherous conditions, and often-solitary existence, light keepers were paid a lower middle-class wage. The first lighthouse keeper in the United States, George Worthylake, received $250 a year for manning the Little Brewster Island station on the Massachusetts shore. In today's money, that would be $16,000 a year. However, during the Gold Rush, West Coast head lighthouse keepers were paid as much as $1,000 a year to keep them working at the stations and not prospecting for gold.

The San Francisco Bay Area has been home to 19 lighthouses, 6 on the approach to the bay and 13 within. There were also lightships stationed outside the Golden Gate, the *San Francisco* and the *Relief,* which directed ships safely into the bay. Images of America: *Lighthouses of the Bay Area* is a photographic journey, presented by geographic regions, from lighthouse technology to the West Coast's first light at Alcatraz Island, to each of the magnificent lighthouses and their keepers that kept the rocky shores of the San Francisco Bay safe for mariners.

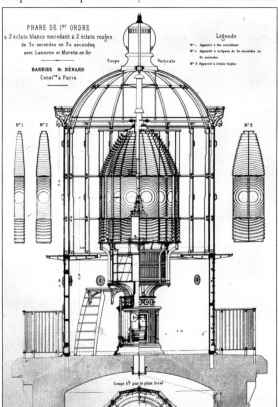

The Fresnel lens, developed in 1822 by French physicist Augustine Fresnel, was a technological marvel and dramatically changed how lighthouses were illuminated. This drawing of a first-order Fresnel lens, written in French, shows the intricacies of the design of the lens and the lantern room that houses the light. (Golden Gate National Recreation Area [NRA], Park Archives, Interpretation Negative Collection.).

One

LIGHTHOUSE
TECHNOLOGY

The purpose of a lighthouse is simple—to provide mariners a guiding light to safely pass rocky coasts, through harbor entrances, and into bay waters. But, as the first lighthouses were built, the technology was primitive. Providing enough light to be visible to a ship out at sea was a daunting task. Early lighthouses were lit by oil lamps, which produced little light and were not very visible far offshore. A variety of reflective devices were tried to increase the brightness, but none was as effective as the Fresnel lens.

In 1822, French physicist Augustine Fresnel developed a giant refracting lens using hundreds of glass prisms with a magnifying bull's-eye lens in the center. The glass prisms were encased in a beautiful, polished brass frame. But the cost for this new marvel had a steep price. Each lens, handmade in France, cost $12,000, plus shipping to the United States.

The original Fresnel lens used a lamp fueled by lard or whale oil, then the fuel changed to kerosene, and finally, by the 1930s, most lighthouses were lit with incandescent bulbs. Oil lamps produce a beam of up to 80,000 candlepower, but the conversion to incandescent bulbs increased beam strength to 4.5 million candlepower, which can be seen more than 20 miles offshore. Before the incandescent bulb, when oil lamps were used, the lenses had to be cleaned daily and the wicks in the lantern trimmed regularly to prevent loss of light, earning keepers the nickname "Wickies."

Fresnel lenses are classified in six sizes called "orders." The largest, first-order lenses, stand 10 to 12 feet tall, measure more than 6 feet (inside diameter), were made of more than 1,000 prisms, and weigh as much as 12,800 pounds. The original lamps in a first-order lens used four to five wicks, burned more than 26 ounces of fuel an hour, and could be seen more than 20 nautical miles. A second-order lens is 6 to 8 feet tall, typically had three wicks, and burned 17.5 ounces of fuel an hour. Second-order lenses were primarily used in the Great Lakes, on islands, and in sounds. The third-order lens is 4 to 5 feet tall, weighs 1,985 pounds, had two wicks, and consumed seven ounces of fuel an hour. These lights were used mostly in sounds, at river and bay entrances, and in channels. The fourth-order lens is 2 to 3 feet tall and can be seen 15 miles at sea. The fifth-order lens, just under 2 feet tall, can be seen 10 miles out to sea, and the sixth-order lens was 1.5 feet tall, had a beam of five miles, and was used at secondary channels, the ends of piers, breakwaters, and jetties.

Vessels could determine their location by the "light characteristics" of the lighthouses. Some lights were fixed, producing a steady beam of light, while others flashed at a constant, repetitive interval. Some lights were colored. Each vessel carried a *Light List*, a book containing all of the characteristics of the lighthouses in each geographical region. Most light stations were also equipped with some type of fog signal, which ranged from a natural, tide-driven blowhole to steam-powered sirens.

After traveling sometimes thousands of miles across the oceans, the glistening beams of light that shine through the night's sky provide mariners with the hope that soon their vessel will safely enter port.

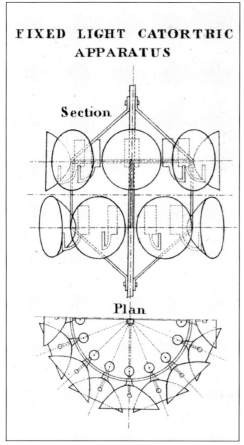

FIXED LIGHT CATORTRIC APPARATUS

Section

Plan

One design used to aid in the magnification of light was the fixed-light catortric apparatus. This drawing shows the cup-shaped holders, made of reflective material, where each candle was placed to intensify the light so it could be seen by passing vessels. (Library of Congress.)

Due to its superior light magnification, the Fresnel lens was adopted by the Lighthouse Board in the early 1850s. All of the West Coast lighthouses were to have the Fresnel lens installed. (Library of Congress.)

This drawing depicts the housing for a fourth-order Fresnel lens. The fourth-order lenses, averaging between 2 and 3 feet tall, were used at harbors, bays, and jetties. (Library of Congress.)

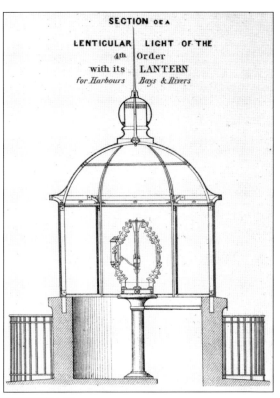

SECTION OF A

LENTICULAR LIGHT OF THE
4th Order
with its LANTERN
for Harbours Bays & Rivers

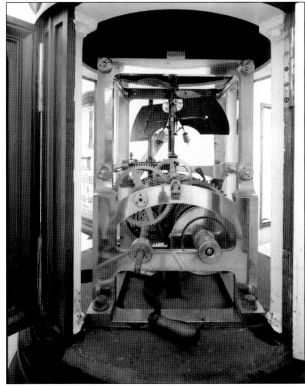

The drive mechanism that turns the lens at the Point Reyes Lighthouse is similar to the mechanism of a timepiece. Note the large crank handle under the mechanism. (Library of Congress.)

11

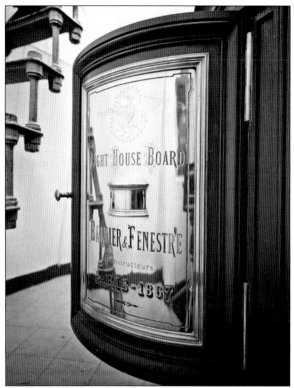

The door to the drive-mechanism area of the Point Reyes Lighthouse shows the beauty of the craftsmanship that went into the lighthouses. The bronze plate on the door shows the manufacturer's information: *Light House Board, Barbier & Fenestre, Constructeurs, Paris–1867.* (Library of Congress.)

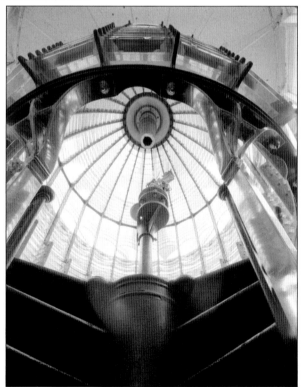

Each of the glass prisms can be seen by looking up into the interior of Point Reyes' large first-order Fresnel lens. (Library of Congress.)

This original construction drawing of the second Alcatraz lighthouse depicts a cutaway of the various aspects of the tower and the keeper's quarters. Note the number of stairs that had to be climbed approximately every four hours to extend the weight that rotated the lens, trim the lantern wick, or perform maintenance. (National Archives.)

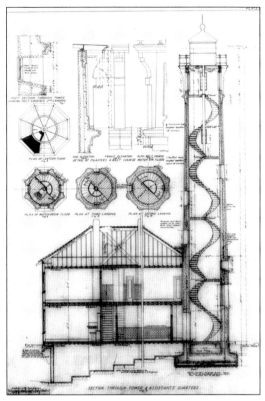

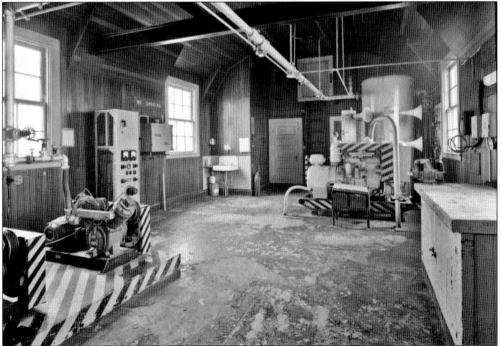

This 1982 interior shot of the Point Reyes fog-signal building shows the fog-warning equipment. (Library of Congress.)

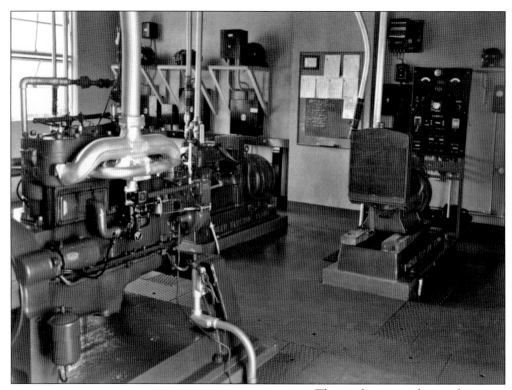

The machinery in this mechanism room shows how much the technology of lighthouses has changed over the years. Lights and fog signals that were once activated by hand are now completely automated. (U.S. Coast Guard.)

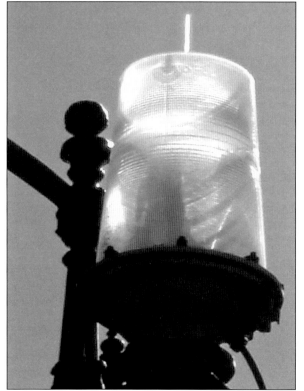

As technology changed, Wickies were replaced with automated lighthouses. In 1970, the Point Montara Lighthouse was automated, and a small beacon was installed in the lantern room to replace the fourth-order Fresnel lens. Even after automation, many systems had a backup. This small beacon was attached to the railing of the tower in case the lantern room beacon failed. (Arlene Bradshaw)

Many of the fog signal bells were automated after power was supplied to the lighthouses. The East Brother Light Station bell was rung by hand while waiting for the boilers to build up enough steam to blow the whistle. When power was brought to the island, this electric bell striker was installed. (Nicholas A. Veronico.)

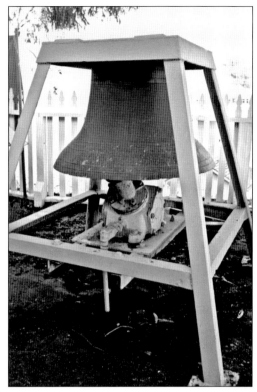

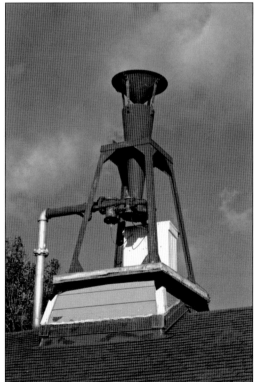

In their glory years, fog signals were bone-shattering loud to warn ships of impending danger. This fog signal, also known as a diaphone, on the East Brother Light Station was run by machinery that compressed the air. When the whistle blew, it was heard for miles around. (Nicholas A. Veronico.)

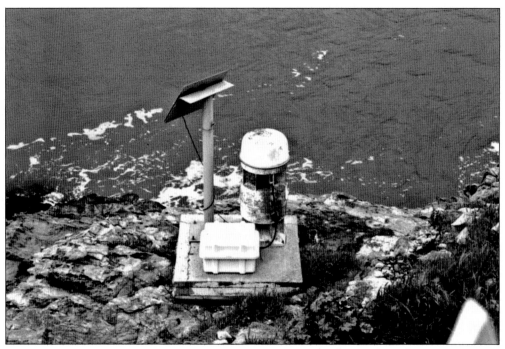

Today, with modern navigation technology aboard ships, the large, booming foghorn is no longer required. A smaller, quieter fog signal sounds on East Brother. This fog signal is solar powered with a battery backup. (Nicholas A. Veronico.)

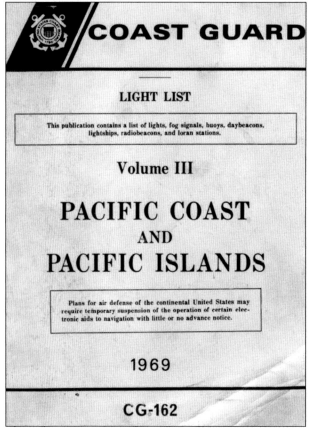

COAST GUARD

LIGHT LIST

This publication contains a list of lights, fog signals, buoys, daybeacons, lightships, radiobeacons, and loran stations.

Volume III

PACIFIC COAST
AND
PACIFIC ISLANDS

Plans for air defense of the continental United States may require temporary suspension of the operation of certain electronic aids to navigation with little or no advance notice.

1969

CG-162

The *Light List* is a publication established by the U.S. Lighthouse Board and now maintained by the U.S. Coast Guard. It describes in detail the characteristics and locations for all aids-to-navigation in each geographic region and, to this day, is revised annually. This 1969 *Light List* is for the Pacific Coast and Pacific Islands. (Author's collection.)

NOTICE TO MARINERS.

(*No. 7, of* 1874.)

UNITED STATES OF AMERICA—PACIFIC COAST CALIFORNIA.

Flashing Light and Steam Fog-Signal, on East Brother Island, off Point San Pablo, in the Straits of San Pablo, connecting San Franciso and San Pablo Bays.

Notice is hereby given that a flashing white light will be exhibited, on and after the evening of March 1, 1874, from a structure recently erected on the western end of the small island off Point San Pablo, in the Straits connecting San Francisco Bay and San Pablo Bay, and known as the East Brother.

The apparatus is of the 4th order of the system of Fresnel, and will show white flashes, at intervals of 30 seconds.

The tower is square, of wood, and is attached to the keeper's dwelling, which is also of wood.

The focal plane is 37½ feet above the base of the building, and 62½ feet above the mean level of low water.

In clear weather, the eye being elevated 15 feet above the water, the light should be seen at a distance of 13½ nautical miles.

The dome of the lantern is painted red, the remainder of the structure of a light buff color.

The geographical position of the light derived from the Coast Survey, is as follows:

> Latitude, 37° 57′ 39″ North.
> Longitude, 122° 26′ 01″ West.

Magnetic variation in September, 1873, 16° 24′ East.

The following are the compass bearings, and distances in nautical miles of prominent objects:

Penole Point, NE. by N. ¼ N., distant four and three-tenths miles.
Point San Pablo, N.E. ¼ E. distant three-tenths of a mile.
East tangent to Red Rock, S. by E. ¾ E., distant two miles.
West tangent to Outer Castro Rock, SE. ¼ S., distant two miles.
West tanget, Southampton Shoal, SE. by S. ½ S., distant three and five-tenths miles.
Wharf at San Quentin, SW., distant two and four-tenths miles.
The Sisters, Eastern Rock, NW. by N. ¼ N., distant one and five-tenths miles.

A 10-inch steam fog-signal is being placed on the island, at its eastern end, 150 feet from the light-house and the machinery will be contained in a small wooden building, painted the same light buff color as the light-house keeper's dwelling.

Due notice will be given of the commencement of this signal.

BY ORDER OF THE LIGHT-HOUSE BOARD:

JOSEPH HENRY,
Chairman.

TREASURY DEPARTMENT,
OFFICE LIGHT-HOUSE BOARD.
Washington, D. C., January 31, 1874.

The *Notice to Mariners* was established as a way of making corrections between annual printings of the *Light List*. This provides mariners with information on changes or additions to the aids-to-navigation in the areas they are traveling. This notice, the seventh for the Pacific area in 1874, announces that the East Brother light and fog signal were to be activated on March 1, 1874. The station's location and equipment are outlined in full detail. (U.S. Coast Guard.)

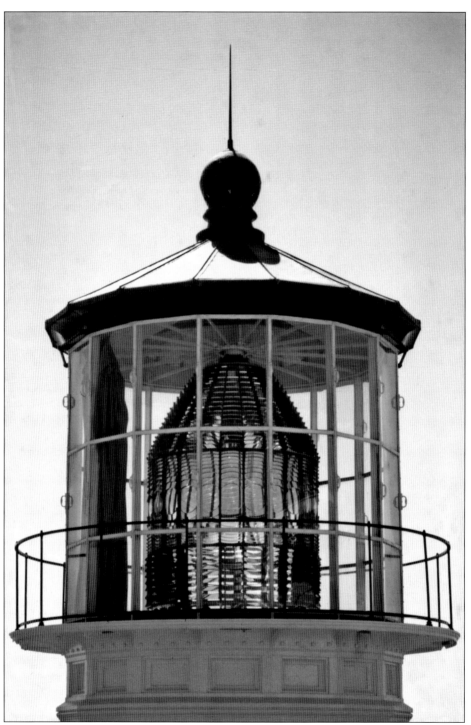

The Point Reyes Lighthouse was equipped with a large, first-order, Fresnel lens that lit the night's sky for the first time on December 1, 1870. The lens turned at a rate of one revolution every two minutes, with a white flash every five seconds. The beam could be seen more than 20 miles out at sea. (John Gaffney.)

Two

APPROACH TO THE BAY
POINT REYES, POINT MONTARA, LIGHTSHIPS, FARALLON ISLANDS, MILE ROCK, POINT BONITA, AND POINT DIABLO

As the Gold Rush in California intensified and vessel traffic increased, aids-to-navigation became desperately needed along the West Coast and in San Francisco Bay. At that time, the U.S. Treasury Department's fifth auditor, Stephen Pleasonton, was in charge of all U.S. lighthouses. Pleasonton had no maritime experience, causing numerous problems, including increasing the numbers of lighthouses but decreasing leadership and maintenance. Pleasonton's tenure lasted from 1820 until October 9, 1852, when Congress appointed a nine-member Lighthouse Board to take control of the floundering lighthouse system. The Lighthouse Board was divided into 12 districts, with the Pacific Coast and Pacific Islands being District 12.

The Lighthouse Board was immediately tasked with two projects: light the West Coast's shoreline and purchase Fresnel lenses for all existing and new lighthouses. One team, lead by Washington A. Bartlett, went to Paris, France, to purchase 63 Fresnel lenses. Then a survey team was sent west to determine the locations most in need of navigational aids. Alcatraz Island, situated just inside the Golden Gate, was selected as the site for the first lighthouse on the West Coast. But the path to the Golden Gate also required navigational beacons.

Lighthouses on the West Coast were initially constructed in the East Coast's Cape Cod cottage–style. It was soon discovered that the West Coast had its own unique coastline and weather conditions, making the Cape Cod–style impractical for most locations. Soon each site was evaluated for its conditions, and a lighthouse design was developed specifically for that location.

One of the foggiest and windiest areas of North America is Point Reyes, located just 35 miles north of the Golden Gate. This was the location of the first recorded shipwreck on the West Coast, the Spanish galleon *San Agustin* in 1595. Despite the continued loss of ships and men, this area remained unmarked for another 275 years. Approximately 20 miles south of the Golden Gate is Point Montara, notorious for its rocky coastline, dense fog, and numerous shipwrecks. The Farallon Islands are a group of small, rocky islands situated 26 miles west of the Golden Gate, with the largest of the islands home to the lighthouse. In 1898, the lightship *San Francisco* was stationed 8.6 miles off San Francisco's coast to mark the approach to the main shipping channel into the bay.

Four-tenths of a mile off the San Francisco shore, two rocks protrude from the water. These rocks are one mile south of the main shipping channel, hence the name Mile Rock Lighthouse. In 1904, a construction crew was hired and taken to the site to view the layout. Upon arrival, the entire crew took one look at the location and promptly quit. A new crew of seasoned sailors was hired, and construction began on the larger of the two rocks. At the north entrance to the Golden Gate is Point Bonita, the location of the third lighthouse on the West Coast and the site of the first "fog signal." The last light station leading to San Francisco Bay is Point Diablo, located on the north side of the Golden Gate halfway between Point Bonita and Lime Point. While not a traditional lighthouse, it provided a much needed aid for passing ships.

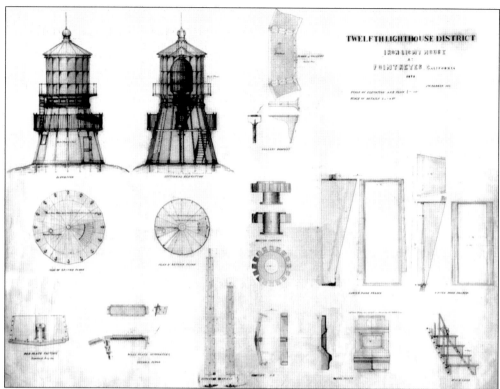

The original drawing of the Point Reyes Lighthouse, dated 1870, shows the design and scale of the structure. The tower is a 35-foot-tall, 16-sided, cast-iron structure with a brick lining. It is painted white with a red roof. (National Archives.)

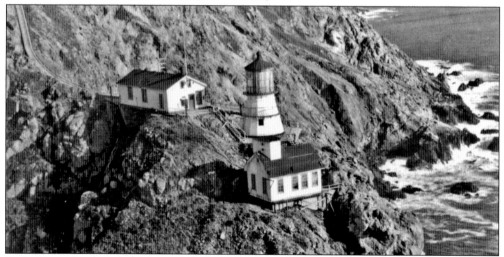

Point Reyes, located approximately 35 miles north of the Golden Gate, is notorious for its wind and fog. Funds to build a lighthouse were allocated in 1854, but local ranchers who owned the land were asking outrageously high prices. Fifteen years later, after the Civil War, the Lighthouse Board resorted to condemnation proceedings against the landowners. With this, the ranchers offered a more reasonable price of $6,000, and 120 acres of land were purchased. The exact site was determined, and construction finally began. (U.S Coast Guard.)

The Point Reyes light was originally going to be built at the top of the hill, but with concerns that the high fog of the area would obscure the light, the plans were changed, and the structure was built 275 feet down the hillside. The original fog-signal building was constructed 100 feet below the lighthouse. Getting the building material to the site was no easy feat. Materials had to be hauled up the cliff from Drake's Beach and then carried down to the construction site. (U.S. Coast Guard.)

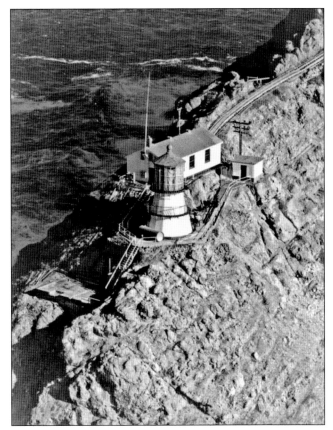

Once completed, there were 308 steps down from the living quarters on the hilltop to the lighthouse, equipment shed, and small oil house. Another 338 steps descended to the original fog-signal building, which burned down twice and was rebuilt. The keeper's quarters can be seen at the top of the hill. (U.S. Coast Guard.)

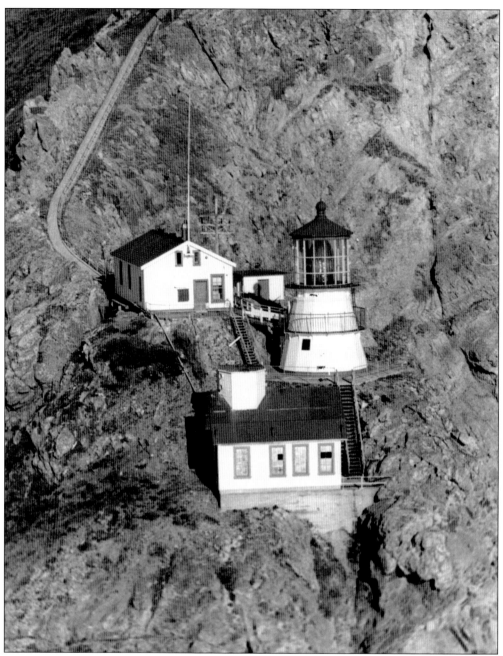

Point Reyes is one of the foggiest lighthouse stations in the United States, with the keeper's logbooks listing an average of 2,100 hours of fog per year. The original fog signal, completed in June 1871, was a coal-powered steam whistle located in a building 100 feet below the lighthouse. Records indicate one episode when the fog rolled in and lasted for 176 hours. During this period, keepers shoveled 24,640 pounds of coal into the boiler. The steam signal was replaced in 1915 with a gasoline-powered diaphone fog signal. Then, in 1934, the fog-signal building was relocated to just below the lighthouse, as pictured here , and was powered by electricity. (U.S. Coast Guard.)

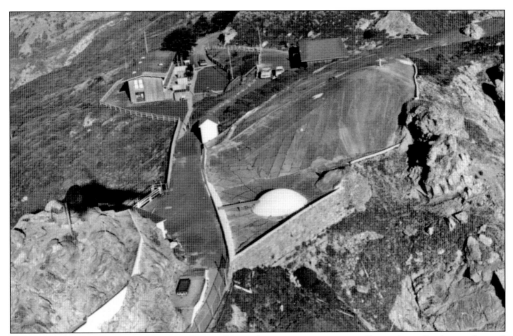

The coal-powered steam fog signal was dependent on rainwater collected in the large domed cistern, seen in the center of the photograph. Without water, there was no steam to produce the signal, which was often the case. During one particular dry spell at Point Reyes, a local rancher hauled in 20,000 gallons of water to fill the cistern. Coal for the steam-powered fog signal was transported down to the fog-signal building by a chute. (U.S. Coast Guard.)

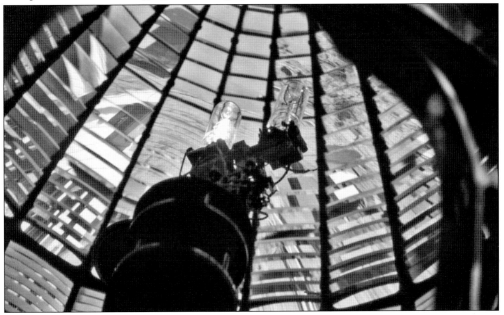

The first-order lens used at Point Reyes is comprised of 1,011 individual glass prisms and 24 bull's-eye lenses. The light can be seen up to 24 nautical miles. The 1930s brought electrical power to the lighthouse; the oil lamp was removed, and a 1,500-watt bulb was installed in the lens. However, the oil lamp was kept on hand in case the power failed, which it did occasionally. (John Gaffney.)

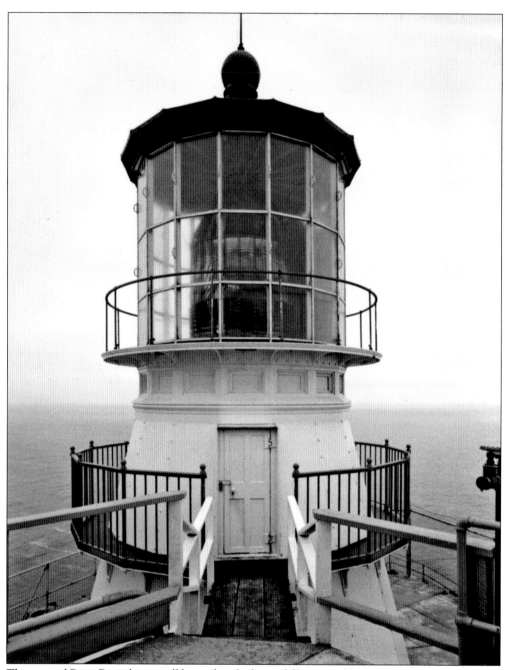

The original Point Reyes lens is still housed in the beautifully restored lantern room, and it is lit twice a month. The lantern room's curtains are closed during the day to avoid discoloration of the glass prisms and to prevent the magnifying bull's-eyes from starting a fire. (Library of Congress.)

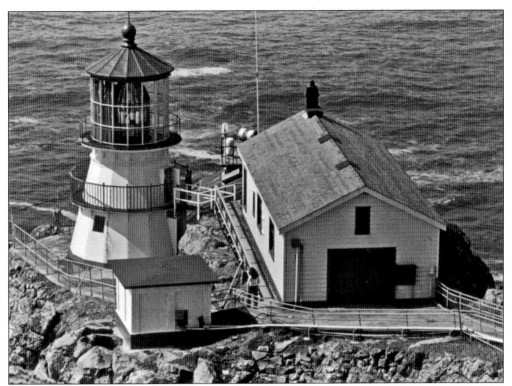

In 1975, the Point Reyes Lighthouse was automated. Looking closely between the tower and the storage shed, the beacon that was attached to the roof of the fog-signal building just below the lighthouse can be seen. (U.S. Coast Guard.)

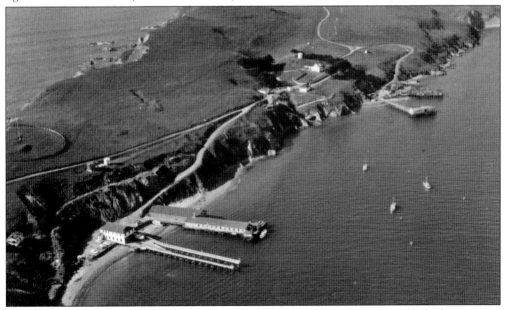

Point Reyes was also home to a lifesaving station. The first station was established in 1890 at Drakes Bay. In 1927, the lifesaving station moved to the calmer waters of Chimney Rock. (U.S. Coast Guard.)

The crew members lived at the lifesaving station. The officer-in-charge and his family had a separate home, seen here, and the seven surfmen had quarters in the boathouse. When a ship was in distress, the lighthouse keepers would sound five short blasts and one 15-second blast on the steam fog whistle to alert the surfmen to the problem. (U.S. Coast Guard.)

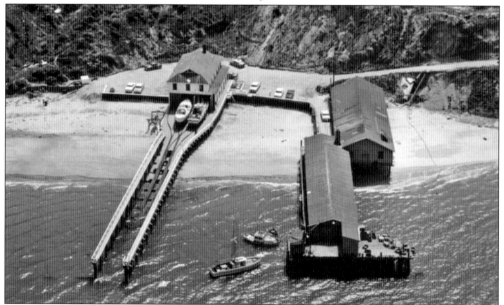

The new station had motorized lifeboats that were better equipped to handle the duties that challenged the surfmen. With the heavier boats, the crews were unable to simply carry them to the surf and row out. A pier was constructed, and the boats were launched into the water by rails. The boathouse could store three 36-foot motorized lifeboats. The crew's quarters, along with an office and galley, were housed above. (U.S. Coast Guard.)

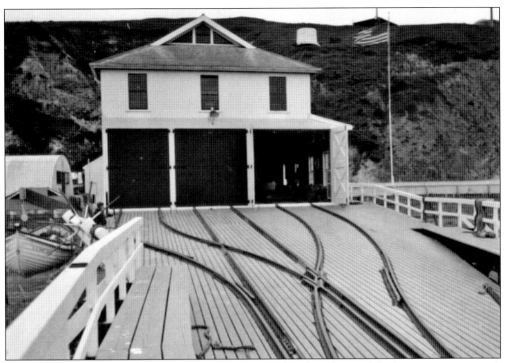

The rails that launched the lifeboats were built like railroad tracks. Each had its own garage track that switched to a single track leading to the water. (U.S. Coast Guard.)

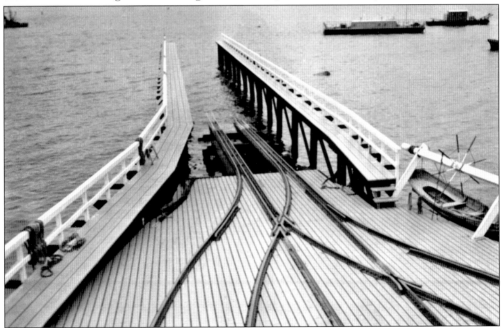

The end of the lifesaving station at Point Reyes came in 1969. Modern technology and the rapid response of the U.S. Coast Guard have made stations like this one unnecessary. Today only a single building remains to mark this historic site. The lifesaving station compound is registered as National Historic Landmark No. 85003324. (U.S. Coast Guard.)

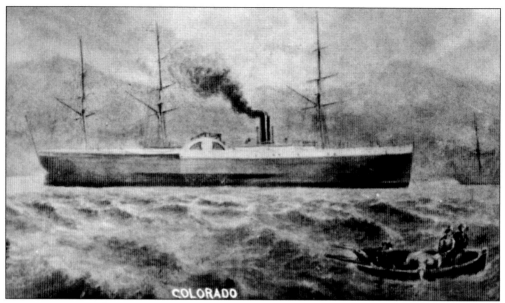

The jagged coast off Point Montara was the scene of nearly 90 shipwrecks by the mid-1800s. On November 9, 1868, the wreck of a Pacific mail steamship, the *Colorado*, carrying hundreds of passengers, caused a public outcry for a fog signal. The ship eventually freed itself from the rocky ledge with all passengers and cargo intact, but the call for a fog signal was not silenced. The October 17, 1872, wreck of the *Aculeo* on what had become known as "Colorado Reef" finally caused a public outcry loud enough for Congress to appropriate $15,000 for a fog signal at Point Montara. (Richard Wheeler Collection.)

Seventy feet above sea level on the rocky bluff of Point Montara, a 12-inch steam whistle was installed. On March 1, 1875, it became operational, and its blast, sounding every five seconds, could be heard up to 15 miles at sea. The steam whistle turned out to be an expensive investment. It took up to 200,000 pounds of coal each year to keep it running. Despite the steam whistle, shipwrecks continued to occur off its coast. (U.S. Coast Guard.)

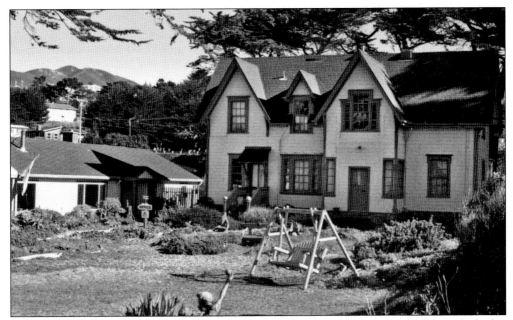

In 1875, the two-story keeper's quarters were also completed. This Victorian Gothic–style duplex mirrored the predominant style of the typical East Coast keeper's quarters. The assistant keepers were housed in a smaller building alongside the main house. The Point Montara Lighthouse was manned by a head keeper and two assistants. Their families also lived at the station. (Author's collection.)

With the shipwrecks continuing along the coast, a kerosene lantern with a red beam that could be seen 12 miles at sea was installed on a post near the steam whistle in 1900. In 1912, this fog-signal building was constructed, and the kerosene lantern was replaced with a fourth-order Fresnel lens housed in a one-and-a-half-story, skeletal, wood-framed structure. (Author's collection.)

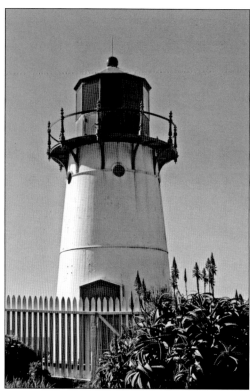

A new 30-foot-tall, metal, conical tower was brought to Point Montara in 1928 to house the Fresnel lens. The lighthouse was fabricated at the Yerba Buena Depot, transported to the site, and then assembled. The fourth-order lens was transferred to the new tower. The beacon flashed white every five seconds to warn the mariners of impending danger of the jagged coastline. (Author's collection.)

During World War II, Point Montara was managed by the U.S. Coast Guard and housed military units, K-9 corps, and a mobile artillery unit. The station proved to be a strategic location for a lookout point on the West Coast. (U.S. Coast Guard.)

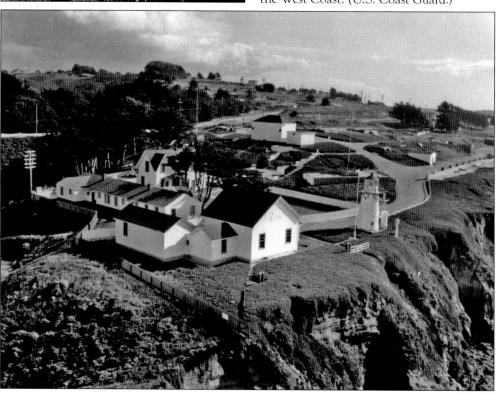

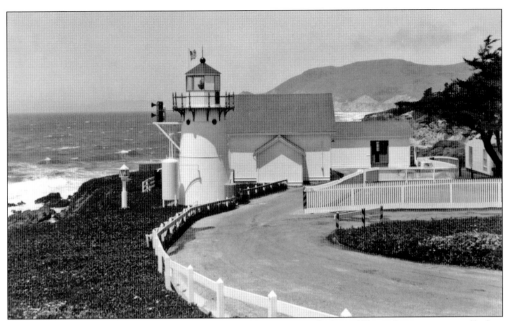

In 1970, the Point Montara Lighthouse was fully automated. An offshore buoy was installed to replace the fog signal, and a small modern lens was installed in the tower to replace the Fresnel lens. (U.S. Coast Guard.)

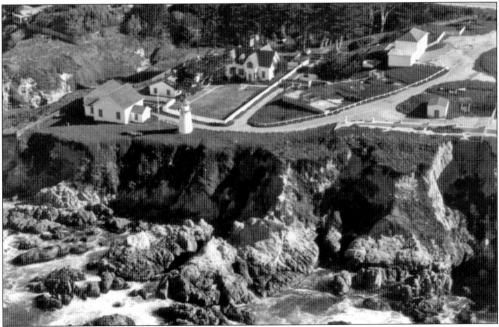

After the automation of the lighthouse, the keeper's home as well as the other houses were no longer necessary. The coast guard was about to tear down most of the structures at Point Montara when, in 1975, California developed a plan to convert five lighthouse stations along the coast into youth hostels. After lengthy negations, a deal was struck and a long-term lease signed. The California legislature set aside $1.9 million for the renovations of the lighthouses, which fell short, but various agencies and local groups rallied to raise the additional funds. (U.S. Coast Guard.)

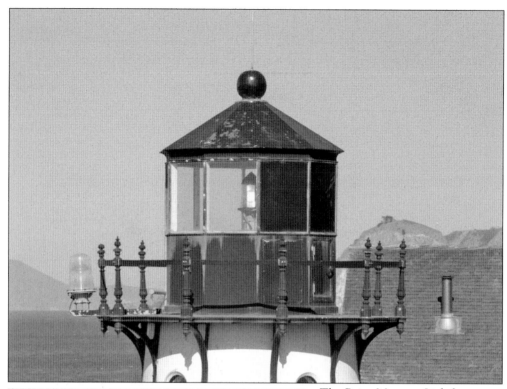

The Point Montara Lighthouse stands today as it did in 1928, with the exception of a small beacon in the tower instead of the beautiful fourth-order Fresnel lens. (Arlene Bradshaw.)

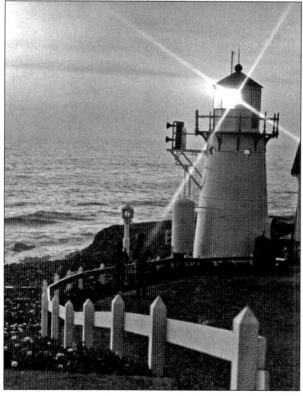

Point Montara Lighthouse Hostel is open to the public for day visits or overnight stays. The weather can be beautiful, with or without the fog. This spectacular photograph shows the lighthouse beaming at sunset on a fogless evening. (U.S. Coast Guard.)

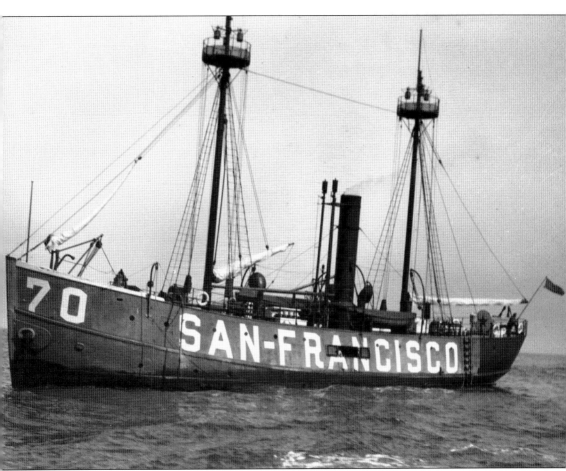

Many areas in need of an aid-to-navigation were located where it was not practical to put a lighthouse; deep water, strong currents, shifting shoals, or areas where it was simply too expense helped limit where lighthouses were built. So lightships played an important role in the Lighthouse Service. The lightships were occasionally moved from one station to another. To help distinguish the ship, the location where the lightship was stationed was painted on the side of the vessel. Light Vessel (LV) 70 was the first lightship called *San Francisco* and was stationed 8.6 miles west of the Golden Gate, marking the main shipping channel into the San Francisco Bay. (U.S. Lighthouse Society.)

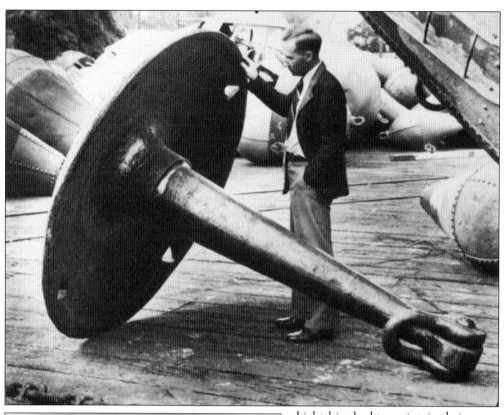

Lightships had to maintain their station regardless of the weather. To remain stationary in one location without drifting required a unique anchor. Lightships were equipped with a large, 6,500-pound, mushroom-shaped anchor that extended from the bow of the ship. Note the size of the anchor in comparison to the man. (U.S. Lighthouse Society.)

On August 23, 1899, the first ship-to-shore radio transmission tests were performed between LV 70 and a receiving station near the Cliff House. The tests lasted 17 days with carrier pigeon messages used to compare the accuracy of the transmissions. After the tests, the equipment was removed from the ship. The tests aboard LV 70 were performed two months prior to the East Coast wireless demonstration by inventor Guglielmo Marconi. (U.S. Lighthouse Society.)

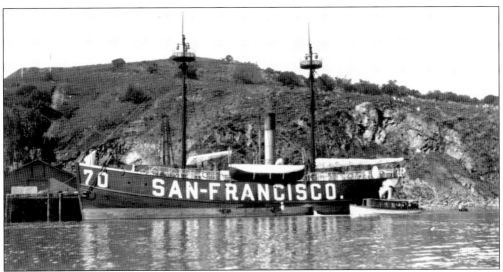

LV 70 is pictured here docked at the Yerba Buena Depot. The ship was in San Francisco for repairs on April 18, 1906, when the earthquake hit. After the shaking stopped, the ship was moved to the Yerba Buena Depot for safety. The fire from the earthquake destroyed the ship's generator and parts of the electrical plant that were ashore for repair. After repairs were completed, the ship returned to its station outside the Golden Gate. (U.S. Lighthouse Society.)

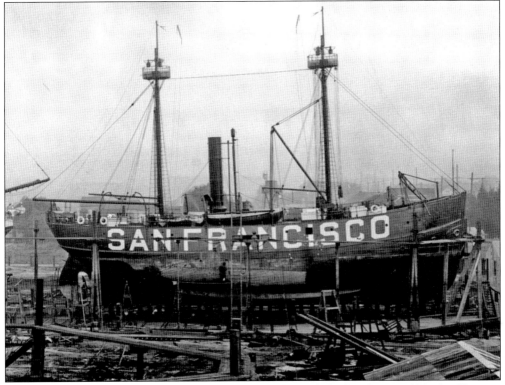

LV 70 began serving San Francisco in 1898 and retired from lightship duty in 1930 after 32 years. The ship was sold on May 21, 1930, and became the cannery tender *Tondelayo*. The ship wrecked in 1941 at Clarance Passage, Alaska. (U.S. Lighthouse Society.)

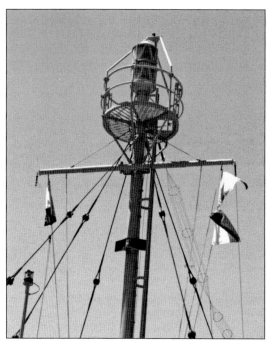

Lightships were equipped with light beacons mounted atop the masts as seen here on the lightship *Relief*. Original beacons were lit by oil lamps; electric lamps were installed in the early 1900s. The ships also were equipped with fog signals. Early fog signals were coal-powered whistles that were eventually replaced by air diaphones. Large bells were used as backup fog signals. In June 1900, the fog whistle on LV 70 was inoperable, and the bell had to be rung by hand for 86 hours. (Nicholas A. Veronico.)

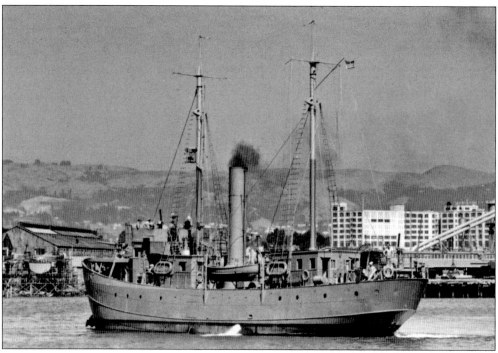

With the retirement of LV 70, Light Vessel (LV) 83 moved from Blunts Reef to San Francisco. In 1942, during World War II, LV 83 was removed from its station and became an examination vessel, armed with a 3-inch deck gun, shown here in military colors. In 1945, after World War II, LV 83 was repainted and resumed duty off San Francisco until 1951, when it was assigned relief duty until it was decommissioned on July 18, 1960. From 1951 to 1969, U.S. Coast Guard Light Vessel (LV) 612 was on station outside the Golden Gate. (U.S. Lighthouse Society.)

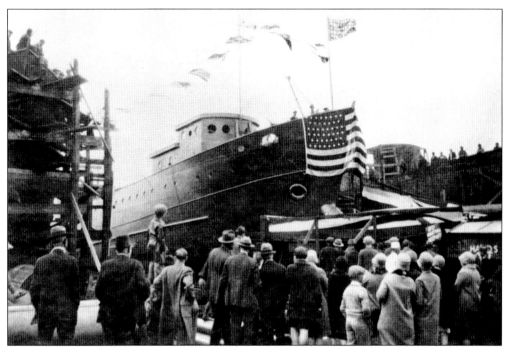

In 1969, LV 100, pictured here being launched at Albina Iron Works in Portland, Oregon, on June 17, 1929, became the fourth *San Francisco* lightship. It had a 375-mm electric lens lantern with a 1,000-watt lamp at each masthead and a fog signal consisting of an air diaphone with a four-way, cast-iron horn. A manual bell was the backup fog signal. (U.S. Lighthouse Society.)

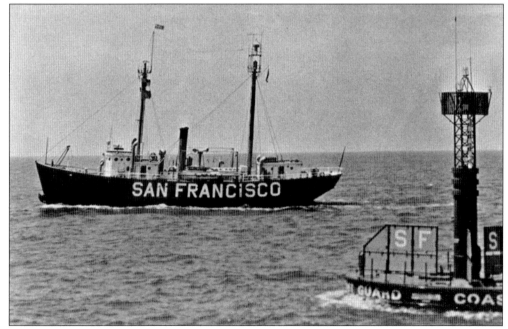

LV 100 gives a final salute to its station in 1971. Decommissioned on May 12, 1971, LV 100 was transferred to the U.S. Navy for use in Vietnam. A beacon was placed where the lightship *San Francisco* had stood guard for 73 years. (Reg McGovern Collection.)

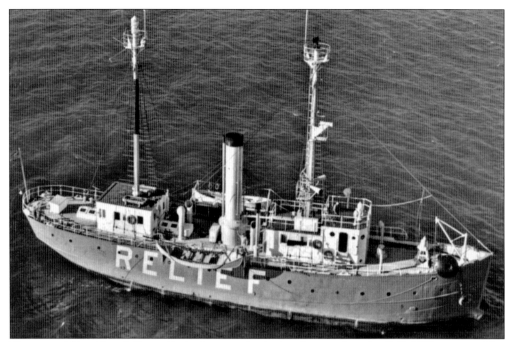

The entire West Coast's fleet of lightships was backed up by one ship, the *Relief*. When one of the ships had to go in for repair, *Relief* would be repositioned at that station. LV 76 (shown here) served as the *Relief* from 1905 to 1942; was stationed at Alameda, California, from 1942 to 1945 during World War II; then worked as the *Relief* again from 1945 to 1960. (U.S. Lighthouse Society.)

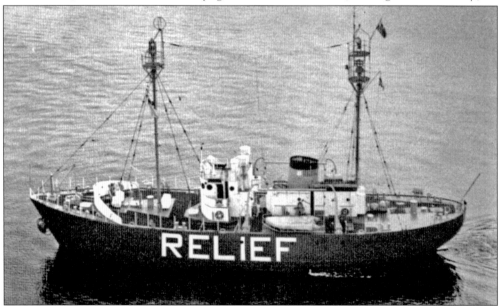

Built in Boothbay, Maine, in 1950, LV 605 began service as the *Overfalls* off Delaware. In 1960, she became the Blunts Reef (*Blunts*) off Cape Mendocino, California. In 1969, she became the *Relief*, then was decommissioned in 1975. *Relief* LV 605 is the last surviving relief ship in the United States. It is currently being restored and is on display at Jack London Square in Oakland, California. (U.S. Lighthouse Society.)

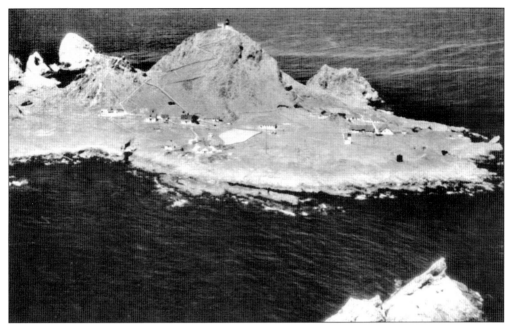

The Farallon Islands are located 23 miles southwest of the Golden Gate. They are a jagged group of three islands, with the largest and tallest being the southwest one, rising 348 feet above sea level. This island was chosen as the location for one of the original 13 lighthouses on the West Coast. The first crew of builders was chased off the island by egg poachers. During the Gold Rush, eggs were taken from the flocks of birds nesting on the islands and sold in San Francisco for as much as $1.50 each. A second crew returned with armed troops and construction of the lighthouse began. (Reg McGovern Collection.)

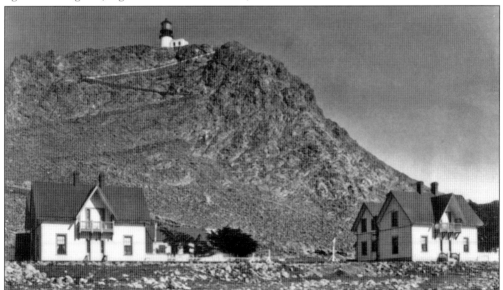

Building a lighthouse on this tall jagged hill was a dangerous and difficult task. Switchbacks were cut into the hillside, and a mule named Jack was brought in to help carry supplies up the hill. The lighthouse was built with a brick and stone round base and a lantern room perched atop. The keeper's quarters were built at the base of the hill. (U.S. Lighthouse Society.)

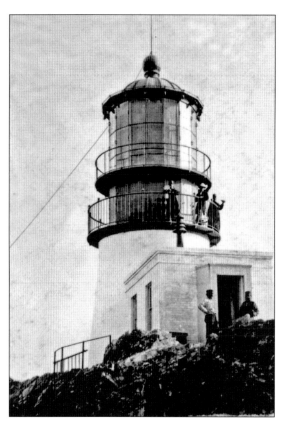

When the large, first-order Fresnel lens arrived on Farallon Island, it was discovered that a serious error had been made, and the lantern room was too small to house the lens. The entire tower was torn down and a new one constructed. The project was completed, and the light's beam could be seen through the fog for the first time on January 1, 1856, flashing once every minute. (U.S. Coast Guard.)

A locomotive whistle mounted over a wave-activated blowhole was the original fog signal at Farallon Island. When the seas were rough and the wind high, the apparatus worked marvelously. However, when the seas were calm and no wind was blowing, which often happened when the fog rolled in, the blowhole whistle was silent. A powerful storm in 1871 destroyed the apparatus, but the chimney still produces blasts of air, as shown in this 1950s photograph of a keeper's wife. (U.S. Lighthouse Society.)

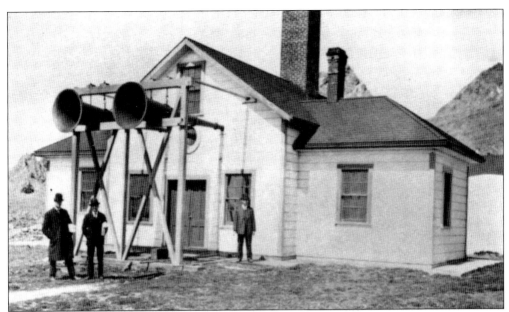

In the mid-1870s, a new fog-signal building was constructed on Farallon Island close to the water's edge to house the much needed steam-powered fog siren. A coal-fired boiler produced steam for the sirens, and the coal was consumed at a rate of 140 pounds per hour. A water cistern and storage tanks were built next to the fog-signal building. (U.S. Coast Guard.)

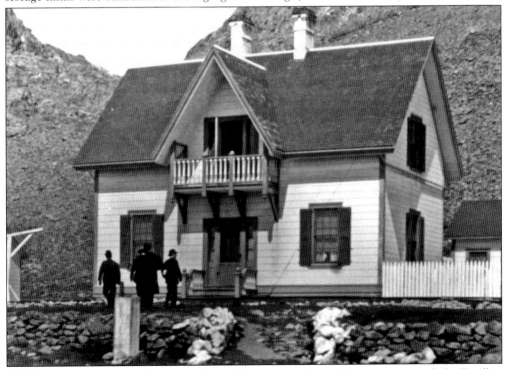

With the completion of the new steam-powered fog signal, additional keepers were needed at Farallon Island. By 1875, two new Victorian-style duplexes were built for the keepers and their families. The keepers' compound was situated on the eastern side of the island. (U.S. Lighthouse Society.)

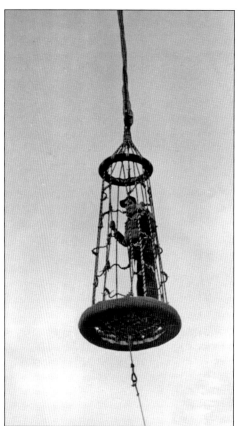

Because of the rocky conditions, Farallon Island did not have a dock; people and supplies were brought in by a derrick. Pictured is a Billy Pugh, a net specifically made to transport people and supplies from the boat to the landing. Billy Pughs were used at many lighthouses. (U.S. Coast Guard.)

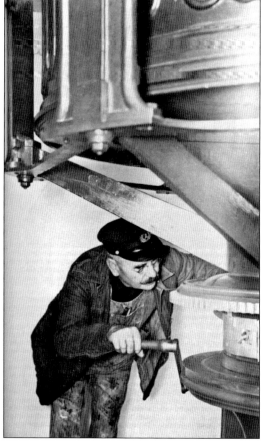

One of the main duties of the lighthouse keeper is to make sure the mechanisms are working properly and to keep the light wound so it showed its correct characteristics. Keeper John Kunder is seen here rewinding the Farallon lights weight to make sure it flashed once every minute. (U.S. Coast Guard.)

Assistant keeper Jen Mikkelson, pictured here in his Lighthouse Service uniform, served the Farallon Lighthouse from 1908 to 1909. (U.S. Lighthouse Society.)

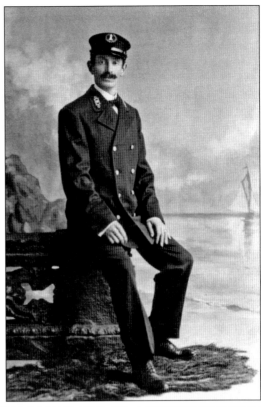

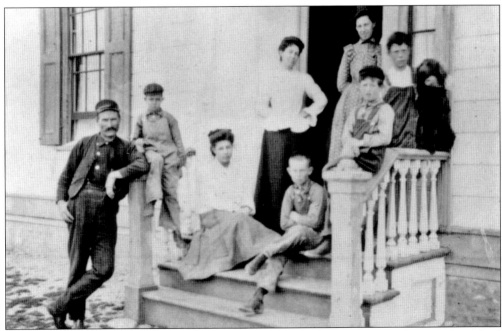

Third assistant keeper ? Kaneen and his family pose on the steps of their home on Farallon Island in 1904. By this time, four families with 10 children lived on the island, which was enough to bring in a teacher. School was taught in the original keeper's home. (U.S. Lighthouse Society.)

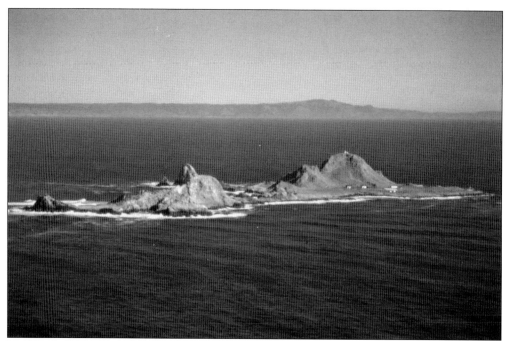

In 1939, the U.S. Coast Guard took control of the lighthouse. The location of the Farallon Islands was perfect for use during World War II. The Farallon Islands was home not only to the coast guard, but also to the U.S. Navy. (John Gaffney.)

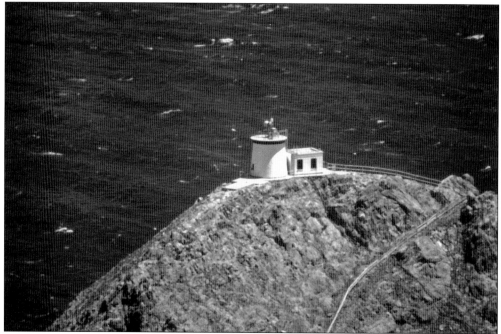

By 1950, the large Fresnel lens was removed from the Farallon Island tower and replaced with a 36-inch diameter airways beacon. In 1962, that beacon was replaced by the current DCB-2-24 beacon. The lighthouse was automated in 1972, the lantern room removed, and the top capped with the DCB-2-24. (John Gaffney.)

The larger of the two Mile Rocks measured 40 feet by 30 feet and stood approximately 20 feet above sea level. In 1904, construction began on the Mile Rock Lighthouse. The top of the rock had to be blasted off to provide a level base for the lighthouse. A round steel-clad tower with 4-foot-thick, steel-reinforced, concrete walls was built to prevent the constant pounding of the waves from destroying the lighthouse. (Reg McGovern Collection.)

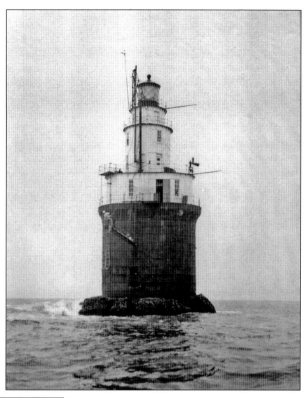

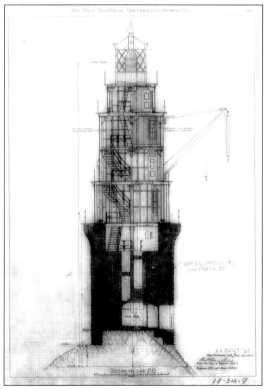

The architect's drawing shows a cutaway of what would become known as the "steel wedding cake." The caisson was built to a height of 35 feet, the second layer that housed the engines for the fog signal was 11.5 feet tall, and the third two-story layer was the living quarters measuring 19 feet. The fourth tier, used for storage, was just over 7 feet tall, and it was topped with a lantern room that housed a third-order Fresnel lens. The light was lit in the winter of 1906 to begin its sentinel over the Golden Gate. (National Archives.)

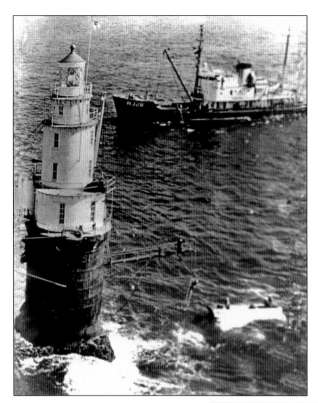

Getting personnel and supplies to the Mile Rock Lighthouse was not an easy feat. People going aboard would grab a Jacobs's ladder at the crest of a wave and quickly climb up the 30-foot ascent as the boat dropped from below. While Mile Rock was close to a major city, it was an isolated station, and there was no room for families. Because of this, the keepers had one week off for every two weeks worked. Many men could not handle the isolation, but keeper Lyman Woodruff served on Mile Rock for 18 years. (Reg McGovern Collection.)

Small items were raised by a rope line thrown from the catwalk and pulled up by hand. Heavy items such as drums of fuel were raised on the east side of the lighthouse where a derrick from the second story was powered by a steam winch. (Reg McGovern Collection.)

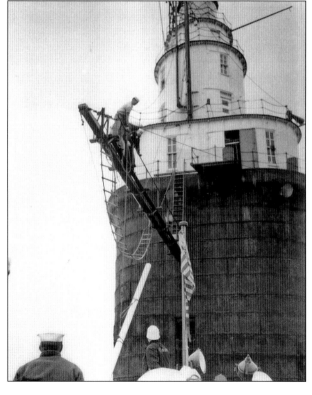

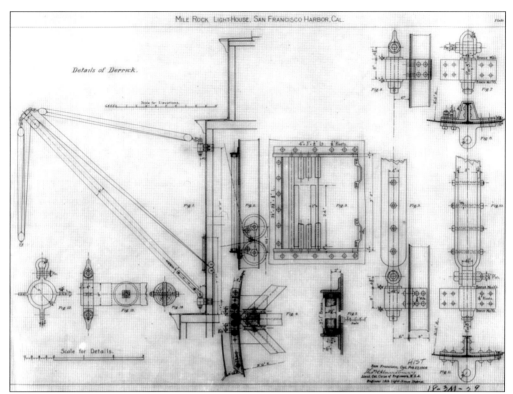

Details of Derrick.

This architect's drawing outlines the details of the derrick that raised and lowered heavy items onto Mile Rock Lighthouse. (National Archives.)

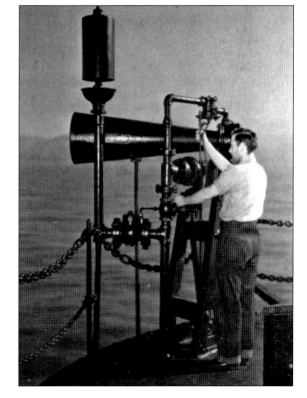

Mile Rock was equipped with a compressed-air fog whistle that blew every 30 seconds when the fog rolled in, which was often. A 20-horsepower oil engine for the whistle was located in the tower's first level. (U.S. Coast Guard.)

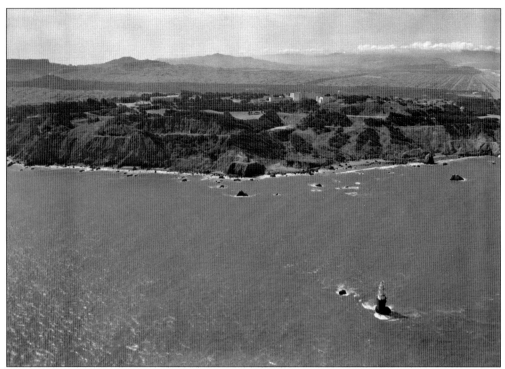

The Golden Gate is a very narrow passage leading into the San Francisco Bay and is often shrouded in fog. The depth through the strait is only 400 feet at its deepest point, and numerous shipwrecks have happened in these waters. This 1960 view faces southeast toward San Francisco's Seal Rock, and shows the two Mile Rocks. (Golden Gate NRA, Park Archives, TASC Negative Collection.)

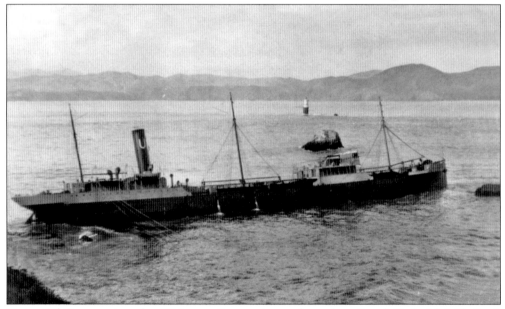

Union Oil Company's tanker SS *Lyman Stewart* sits on the rocks at Lands End with Mile Rock in the background. On October 7, 1922, the ship collided with SS *Walter Luckenback* in thick fog at the Golden Gate. (Richard Wheeler Collection.)

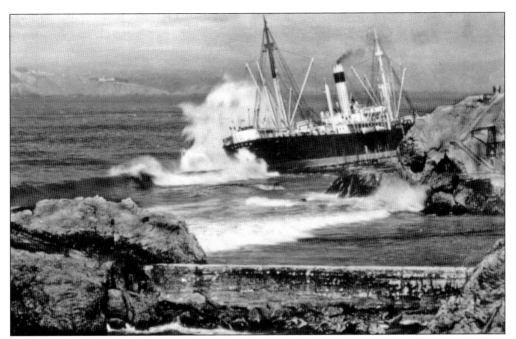

When the captain and pilot lost their bearings in dense fog on October 6, 1936, the freighter *Ohioan* ran aground near the Cliff House. Large crowds watched as heavy seas crashed over the wreck. The crew was rescued, and her cargo of washing machines, trucks, and general merchandise were salvaged. The rusted hull littered the shore for two years until a storm finally destroyed the remains. (Richard Wheeler Collection.)

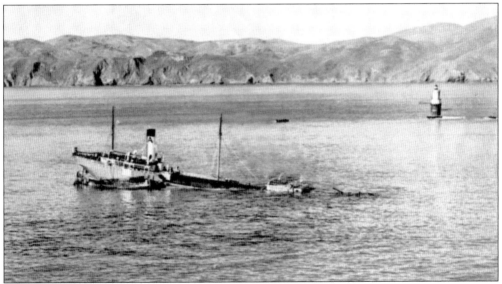

On March 3, 1937, Associated Oil Company's tanker *Frank Buck* and the SS *Coolidge* collided off Lands End. Most of the crew escaped by the ship's lifeboats, but eight crew members and the ship's dog were rescued by a boat from the Point Bonita Coast Guard Station. Mile Rock Lighthouse can be seen in the background, but the fog was too thick for even the light and foghorn to prevent the accident. The *Frank Buck* came to rest near her sister ship, Union Oil Company's SS *Lyman Stewart*. (Golden Gate NRA, Park Archives, Fort Point Collection.)

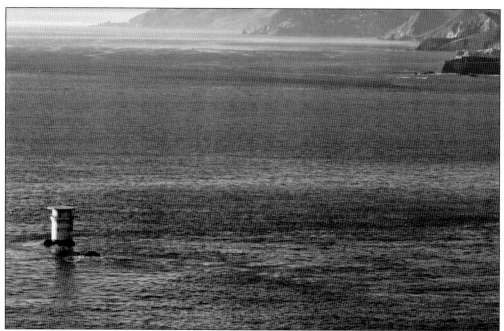

In 1966, with little regard to the public outcry, the U.S. Coast Guard automated the Mile Rock Lighthouse as a cost-saving measure. With this came the dismantling of the top tiers of the lighthouse. The only item remaining from the top part of the tower is the third-order lens, which was installed at Old Point Loma Lighthouse in San Diego, California. (Nicholas A. Veronico.)

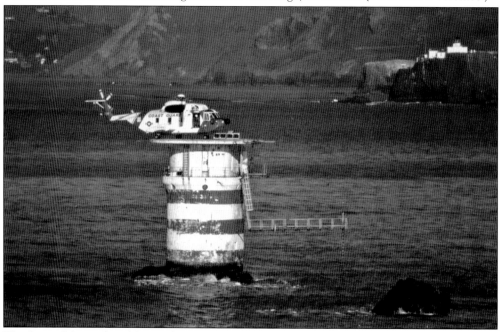

The beautiful "steel wedding cake" is gone, and all that is left is the caisson, now painted in orange and white stripes, with a helicopter landing pad on top. The coast guard still maintains the automated light by either boat or helicopter. Point Bonita Lighthouse can be seen in the background. (John Gaffney.)

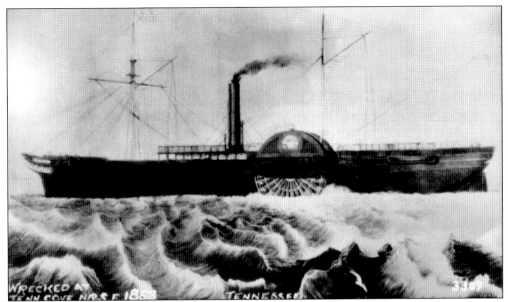

On March 6, 1853, Capt. Edward Mellus of the side-wheel steamship *Tennessee* attempted the journey into the bay, but the swift outgoing tide proved too much for the ship. Unknown to the captain because of the thick fog, the ship was swept north toward Marin. The rocks that appeared were not Mile Rock, as he thought, but the Marin coastline. The captain ran the ship aground at what was to be known as Tennessee Cove near Point Bonita. All passengers, gold, mail, and baggage were saved, but the ship was a total loss. (Richard Wheeler Collection.)

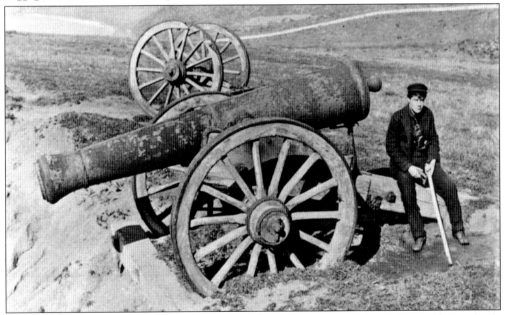

With the Point Bonita Lighthouse situated 260 feet above sea level, the light would completely vanish into the foggy mist. To aid the lighthouse, this surplus 24-pound cannon was purchased as the first fog signal of the West Coast. On August 8, 1855, retired army sergeant Edward Maloney was hired to fire the cannon every 20 minutes in foggy weather, which proved to be tiresome task. (Golden Gate NRA, Park Archives, Point Bonita Fog Cannon Collection.)

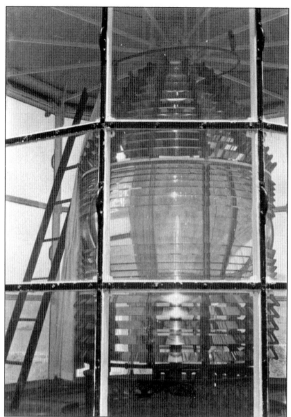

On May 2, 1855, the original Point Bonita Lighthouse was lit by the keeper. The large second-order Fresnel lens could be seen up to 18 miles at sea, but with the height of the tower, the light was obscured from mariners when heavy fog rolled in. (Golden Gate NRA, Park Archives, Interpretation Negative Collection.)

Plans were developed to build a new lighthouse lower on the hill on the southwestern tip of Point Bonita, but access was a problem. In 1876, a crew that worked on the Sierra tunnels was hired to dig a 118-foot tunnel through the solid rock hillside to access the ideal location. One year later, the new lighthouse was completed. It was a one-story building with the middle section reinforced to support the old lantern room and lens. (Golden Gate NRA, Park Archives, Interpretation Negative Collection.)

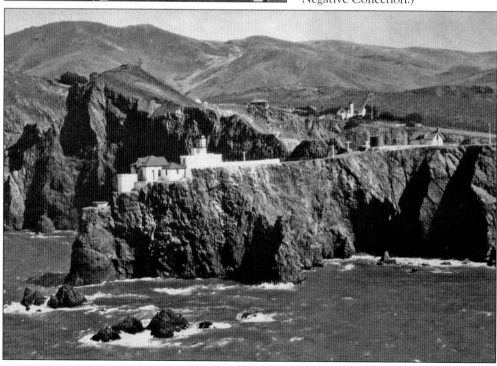

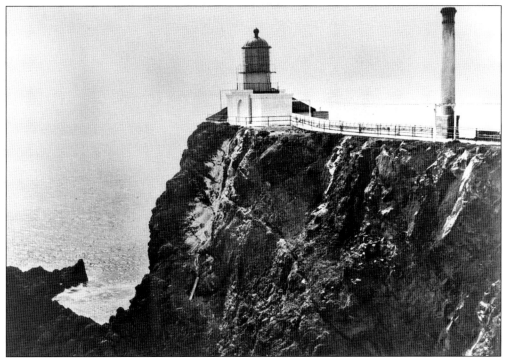

The new Point Bonita Lighthouse flashed its beacon for the first time on February 2, 1877. The new site was 124 feet above sea level, making the light much more effective. A steam siren fog signal was erected in front of the lighthouse in 1902 that produced a five-second blast every 35 seconds. The brick chimney and flue of the fog signal can be seen on the right. (Golden Gate NRA, Park Archives, TASC Negative Collection.)

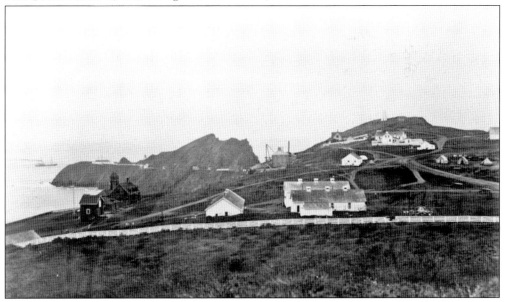

Looking west in this 1906 view, the engineer's compound is in the foreground, and other support structures for the Point Bonita Lighthouse are scattered throughout the area. (Golden Gate NRA, Park Archives, TASC Negative Collection.)

Second assistant keeper Niles C. Frey, who served at Point Bonita from 1896 to 1900, is pictured in his Lighthouse Service uniform. (Golden Gate NRA, Park Archives, Frey Family Point Bonita Lighthouse Collection.)

While many lighthouse stations were isolated, others had comfortable accommodations for the keepers and their families. Keeper Niles Frey and his family are pictured on the steps of one of the original Point Bonita keepers' quarters. (Golden Gate NRA, Park Archives, Frey Family Point Bonita Lighthouse Collection.)

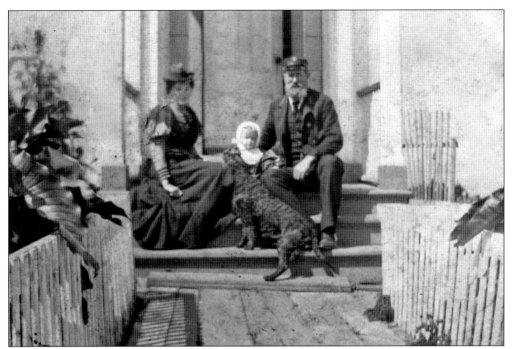

Second assistant keeper Niles Frey, his wife, Agnes, and their daughter, Olga, pose on the steps of their home at the Point Bonita Lighthouse. (Golden Gate NRA, Park Archives, Frey Family Point Bonita Lighthouse Collection.)

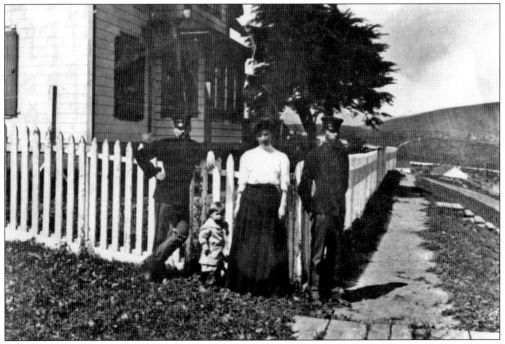

Two Fort Berry soldiers are seen here in 1909 with a Point Bonita keeper's wife and child. Fort Berry was located in the Marin Headlands, very close to the lighthouse. (Golden Gate NRA, Park Archives, Interpretation Negative Collection.)

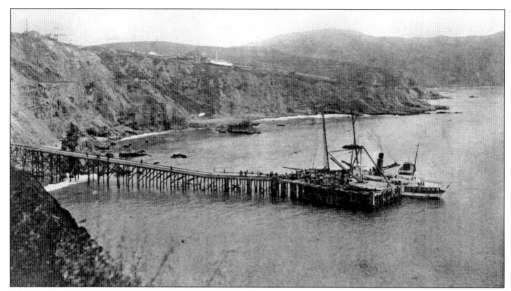

The Point Bonita Lighthouse used a large amount of coal, some for the keepers' quarters but most for the coal-hungry boilers of the fog signal. A dock and tramway were built so coal could be off-loaded from supply ships and brought up the tramway in hopper cars. (Golden Gate NRA, Park Archives, Fort Barry Photograph Collection.)

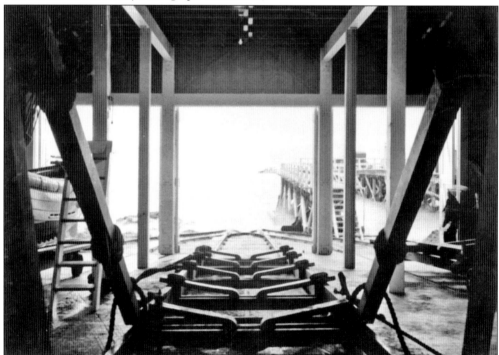

Point Bonita also had a lifesaving station. Nine surfmen were assigned to the station, which was located on the edge of Bonita Cove. The station consisted of a boathouse with a rail launch way, a lookout tower, and crew's quarters. The station was equipped with a surfboat and a lifeboat, as well as a breeches buoy, a line cannon, and a beach cart with a team of horses. (Golden Gate NRA, Park Archives, USCG Point Bonita Collection.)

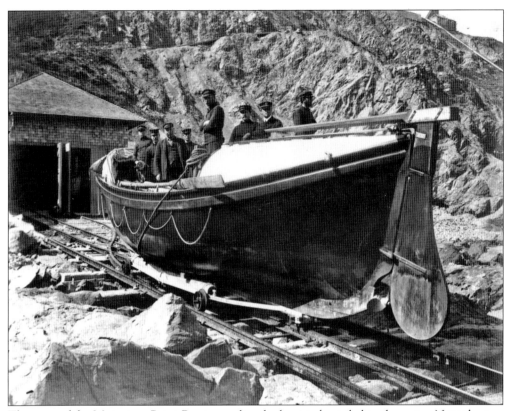

The crew of the *Majestic* at Point Bonita readies the boat to be railed to the water. Note the two tracks coming out of the boathouse and the three-rail track. (Golden Gate NRA, Park Archives, USCG Point Bonita Collection.)

Point Bonita once had land between the lighthouse and the tunnel. In 1940, erosion finally took its toll, and a landslide removed a large section of the pathway. A temporary causeway was built until the suspension bridge that mirrors the Golden Gate was built in 1954. (U.S. Coast Guard.)

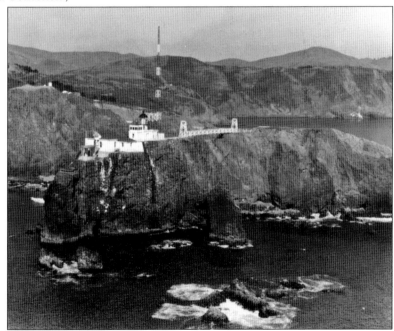

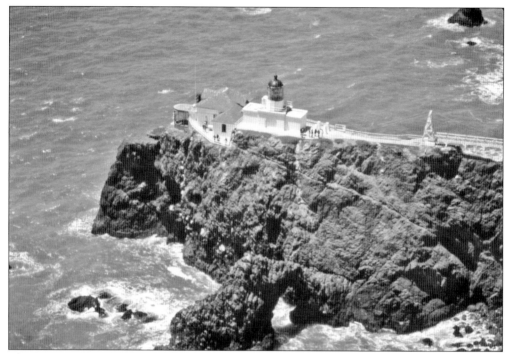

The Point Bonita Lighthouse was automated in April 1981, relieving the last manned lighthouse along the California coast from its duties. The U.S. Coast Guard maintains the light and fog signal, but the National Park Service now runs the Point Bonita Lighthouse. (John Gaffney.)

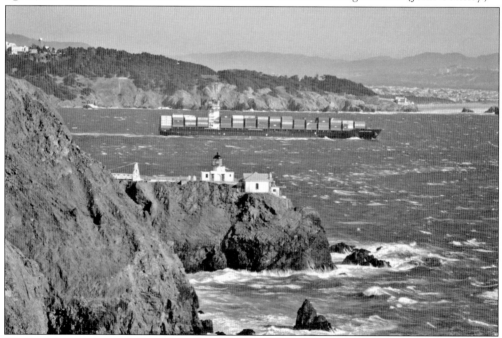

While no longer manned, Point Bonita is still an active aid-to-navigation. Here a large container ship heads out of the San Francisco Bay past Point Bonita. Like many other ships, it depends on the lighthouses to guide the way when the local fog rolls in. (Nicholas A. Veronico.)

The area between Point Bonita and Lime Point along the Marin coastline was a treacherous stretch of shore, with Point Diablo being the most dangerous location. The tip of Point Diablo extends into the Golden Gate some 600 feet. In 1923, a small, white building was constructed 80 feet above sea level at Point Diablo. While not a traditional lighthouse, the structure housed two lenses and a 12-inch electric siren. (Kraig Anderson.)

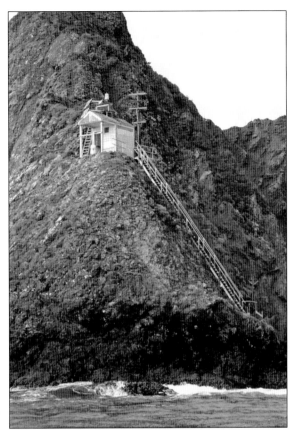

Point Diablo was a semiautomatic station, with the keepers at Lime Point responsible for maintaining it. The Lime Point keepers listened in by way of a telephone that was connected by electric lines. The keepers had to visit the site every week to clean the lenses and oil the fog signal. The lighthouse was fully automated, with solar panels powering the systems. The beacon attached to the roof of the building flashes every six seconds, and the small round device in front is the automated fog signal. (Kraig Anderson.)

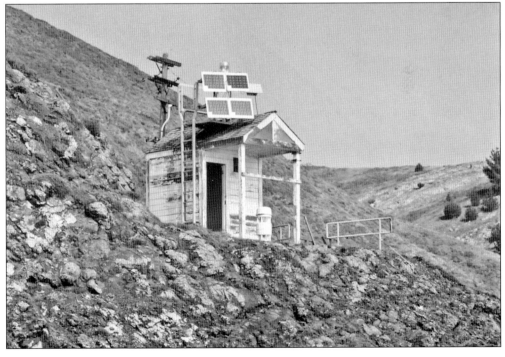

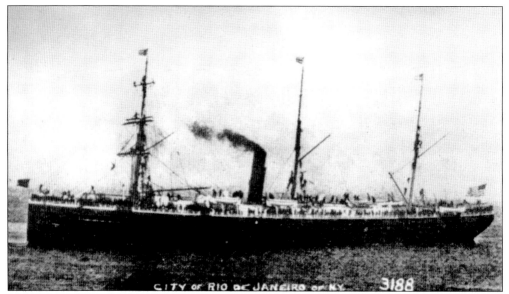

The sinking of the SS *City of Rio de Janeiro* was the worst maritime disaster in San Francisco's history. The ship was returning to its homeport of San Francisco with 220 passengers and crew onboard. On February 22, 1901, in heavy fog, the ship tried to maneuver through the narrow Golden Gate but struck rocks at or near Fort Point and quickly began sinking. The language barrier between the American officers and the mostly Chinese crew prevented the launching of the lifeboats. Approximately 130 lives were lost. (Richard Wheeler Collection.)

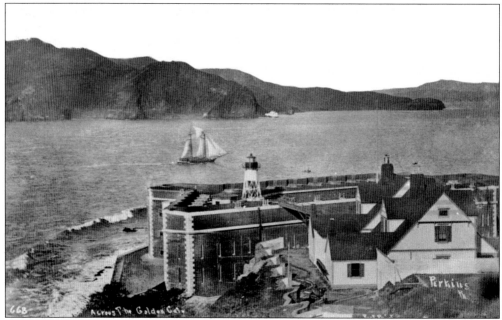

In 1864, a lighthouse was built on the roof of Fort Winfield Scott. The three keepers' quarters were built on the south side of the fort. Two were on the bluff opposite the top of the fort, and the third was at the base of the bluff. Originally, the keepers entered the fort and climbed a spiral staircase to access the lighthouse. In 1876, a bridge was built to span the gap between the bluff and the top of the fort, as seen here. (San Francisco Public Library.)

Three

INSIDE THE BAY
FORT POINT, LIME POINT,
ALCATRAZ ISLAND, AND ANGEL ISLAND

As ships passed through the majestic Golden Gate, two lighthouses once guided the way. On the north shore sits Lime Point. The original station, completed in 1883, consisted of a fog-signal building, a two-story structure that housed the keepers, and other smaller support structures. A 300-mm lens, standing only 19 feet above sea level, was eventually added to the fog station. While most of the buildings were demolished and the one remaining old fog-signal building is in serious disrepair, the light guides ships through the channel to this day.

To the south of the Golden Gate is Fort Point. The second lighthouse on the West Coast was built at this location but was never lit. While awaiting delivery of the third-order Fresnel lens from France, the U.S. Army decided this was a strategic location for a fort to defend San Francisco Bay. The original lighthouse was torn down, and Fort Winfield Scott was constructed. In 1855, a 36-foot-tall wooden lighthouse with a fifth-order lens was built on a ledge between the fort and seawall. The sea conditions proved too much for the wooden structure, and in 1863, only eight years after its construction, the second lighthouse in this location was torn down. In 1864, a 27-foot iron tower was built on the roof of the fort with a fourth-order Fresnel lens.

Alcatraz Island, located in the middle of San Francisco Bay, was selected as the site for the first lighthouse on the West Coast. The foundation for the two-story, Cape Cod–style cottage was laid in late 1852 and the structure completed in July 1853. However, the newly created Lighthouse Board ordered the installation of a Fresnel lens instead of the planned Argand lamp and parabolic reflectors. The fixed third-order Fresnel lens arrived, and the first West Coast lighthouse of the United States lit the night's sky on June 1, 1854. The fog in the San Francisco Bay can be very thick. Many times even the strong light from the Fresnel lens could not penetrate the heavy fog. Two fog bells, one at the north end of the island and one at the south end, were added to help guide ships safely around the island.

With the damage sustained in the 1906 earthquake, and to make room for a federal maximum-security prison, the first lighthouse built on the West Coast was demolished in 1909. Subsequently, an 84-foot-tall lighthouse tower was erected next to the prison cell house and was placed into operation in December 1909.

Angel Island, the largest island in the San Francisco Bay, housed three light stations. Point Knox, on the west side of the island, was the location for a fog bell, which was installed in 1886. In 1900, a fifth-order red lens was added to the location. In 1915, a second light was installed on Angel Island at Point Stuart, about half a mile north of Point Knox. The Point Stuart light guided ships between the island and Tiburon, as well as marking Raccoon Strait, so named for the ship, HMS *Raccoon,* which sank there in 1814. A third light at Point Blunt was added in 1960 on the southeast side of the island to guide vessels into the shipping lanes for the Sacramento and San Joaquin Rivers. While a green light still shines from the watch building at Point Blunt, today Angel Island is a state park, and only a few remnants of the light stations remain.

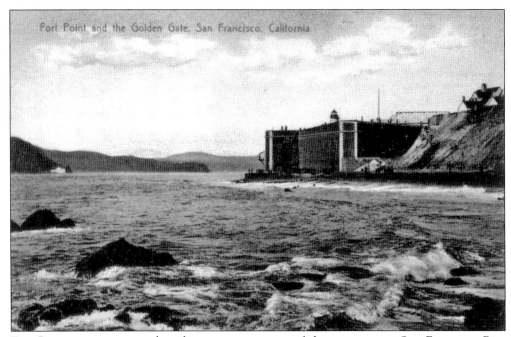

Fort Point was constructed at the narrowest point of the entrance to San Francisco Bay. Construction began on the three-story fort in 1854 and took seven years to complete. Because the lighthouse was perched on top, the beam from the lighthouse was 106 feet above sea level. (Author's collection.)

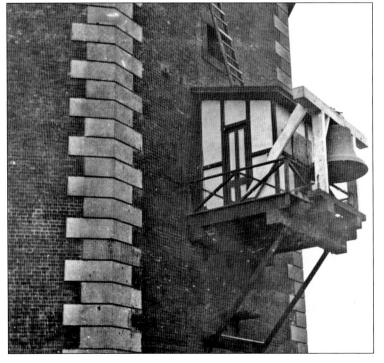

The original fog signal was a large bell housed on the outside of the fort facing the ocean. When the mechanical striker failed, a keeper or one of his family members had to climb down the ladder, shown at the top of the bell house, and strike the bell manually, which was a frightful task with the wind in the area. In 1904, the bell was replaced with a Daboll trumpet fog signal. (Golden Gate NRA, Park Archives, USGC Fort Point Collection.)

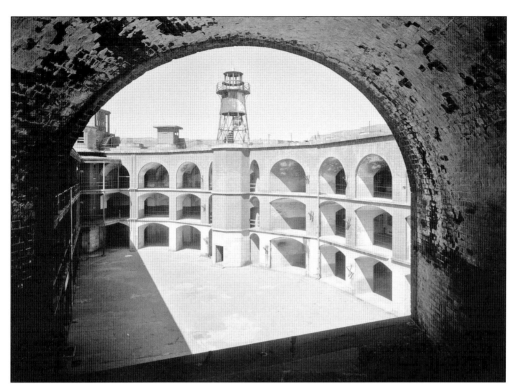

From inside the fort, the lighthouse can be seen standing guard, just like the soldiers did years ago. Cannons once lined the roof, alongside the lighthouse, of the red brick and mortar fort. (Library of Congress.)

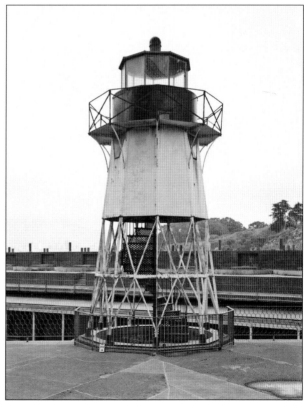

The Fort Point Lighthouse is an iron, nine-sided, skeletal tower standing only 27 feet tall. A spiral staircase led up the middle to the black lantern room, which housed a fifth-order Fresnel lens. In 1902, the lens was changed to a fourth-order lens with an alternating red and white flash. A 70-pound weight was used to revolve the lens. The weight required winding every two-and-one-half hours. (Library of Congress.)

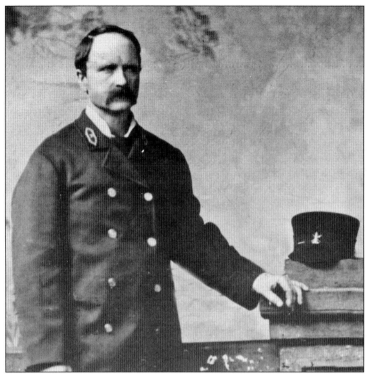

Keeper James Rankin served at Fort Point from 1878 until 1919. Rankin lived in the keeper's quarters at the base of the bluff with his family. During his 40-year career at Fort Point, Rankin received commendations for saving the lives of 18 people. (Golden Gate NRA, Park Archives, Fort Point Collection.)

Shown in front of the two keepers' quarters on the bluff in 1908, men stand beside the hand-cranked tram they made to haul supplies up the steep cliffs. (Golden Gate NRA, Park Archives, Fort Point Collection.)

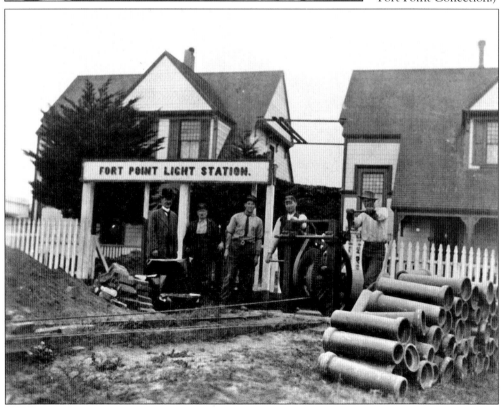

FORT POINT LIGHT STATION.

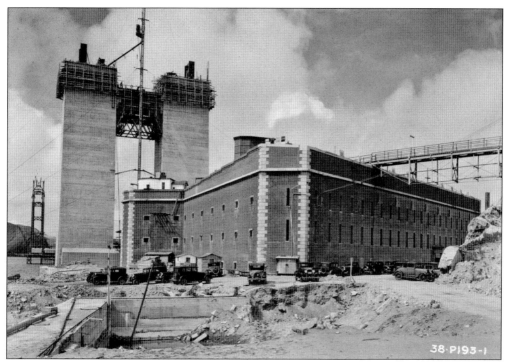

Construction on the Golden Gate Bridge began in 1933. The massive tower anchoring the south end of the bridge stands high above Fort Point. (Library of Congress.)

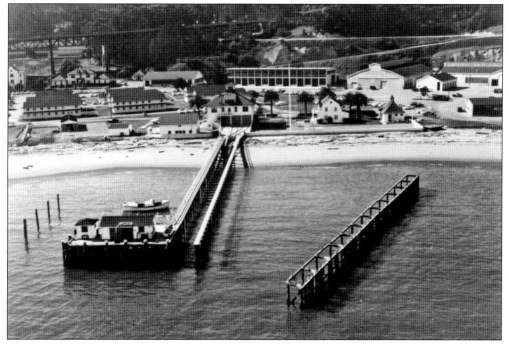

Fort Point was home to a lifesaving station, located on Crissy Field, as well as the lighthouse. The boathouse could accommodate three lifesaving boats that were launched by railway. (Golden Gate NRA, Park Archives, USCG Fort Point/Fort Bonita Collection.)

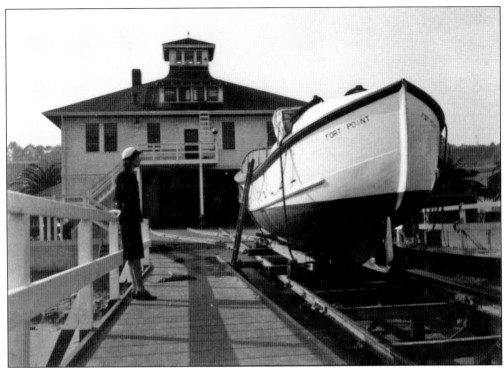

This 1945 photograph shows the marine railway at Fort Point/Crissy Field with a lifesaving boat perched on the railway. A woman in her SPAR uniform stands beside the rail. SPAR is another term for the U.S. Coast Guard Women's Reserve. (Golden Gate NRA, Park Archives, USGC Fort Point Collection.)

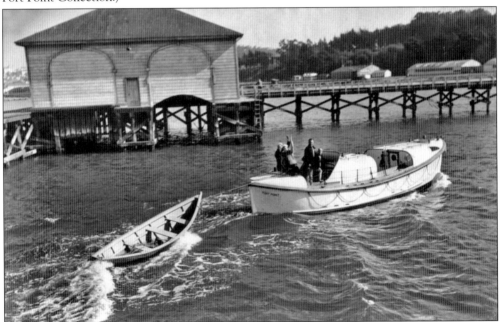

A Fort Point lifesaving boat pulls a small rowboat ashore, its passengers safely onboard with the surfmen. (San Francisco Public Library.)

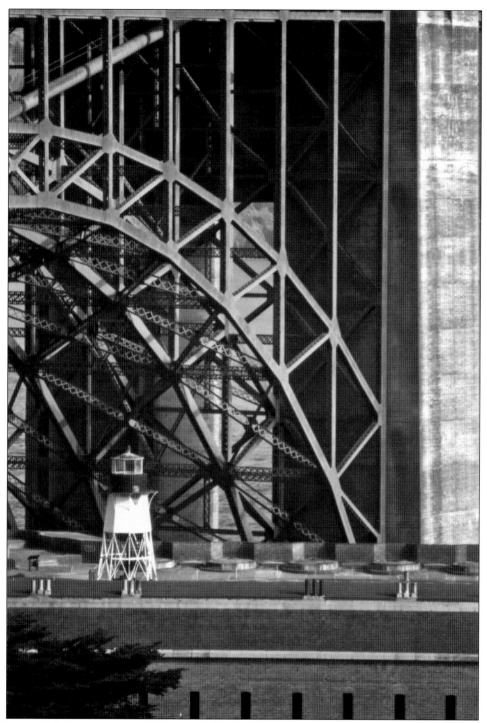

The tiny lighthouse atop the fort became obscured by the massive Golden Gate Bridge. Fort Point Lighthouse dimmed its beam for the last time on September 1, 1934. An automated beacon and fog signal were installed at the base of the bridge's south tower. On October 16, 1970, Fort Point became a National Historic Site. (John Gaffney.)

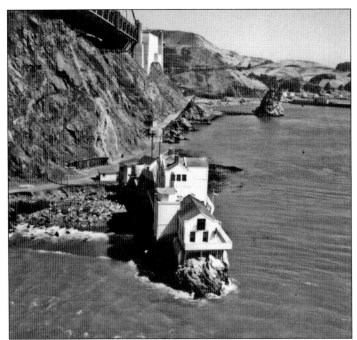

Lime Point, situated on the north side of the narrow Golden Gate passage, was originally built as a fog station. The one-story fog building and a large, two-story, brick building to house two keepers and their families were completed in September 1883. A third story was added to the keepers' quarters several years later. In 1900, a 300-mm lantern that flashed white every five seconds was installed on the wall of the fog-signal building to help guide ships through the narrow channel. (U.S. Coast Guard.)

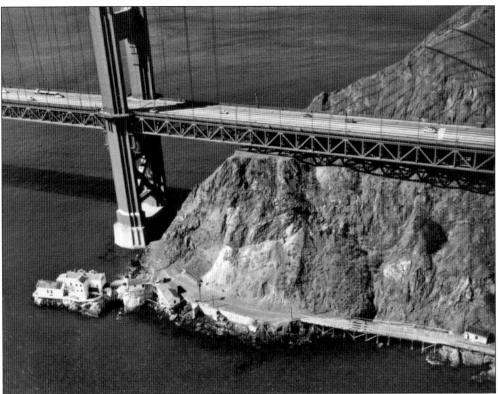

When the Golden Gate Bridge was completed in 1937, it stood directly above the Lime Point Lighthouse. This brought on a new hazard for the keepers—debris being thrown from the bridge, which could cause serious injury if it landed on someone below. (U.S. Coast Guard.)

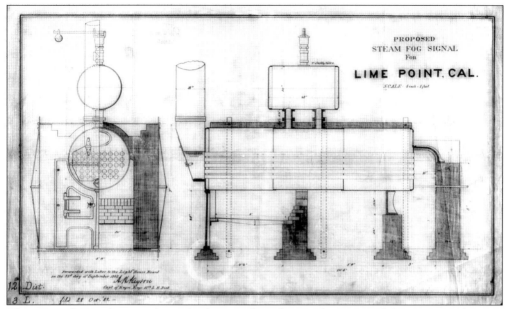

This original 1883 drawing shows the fog-signal machinery that powered the two 12-inch steam whistles. Keepers would shovel as much as 150,000 pounds of coal per year into the boilers to keep the whistles active in the fog. To save money, the Lighthouse Service experimented with converting the fog-signal machinery from coal to oil. The experiment was successful. The daily cost for running the signal went from $25.44 with coal to $6.91 for oil, and the keepers no longer had to spend countless hours shoveling coal. (National Archives.)

As the keepers tended the lighthouse on foggy June 3, 1960, a large jolt rocked the station. Despite both the fog whistle and lantern working, the 440-foot freighter *India Bear* veered off course and rammed the lighthouse. Damage to the station included the air pipes for the fog whistle, a bathroom, and the building, which cost $7,500 to repair. (U.S. Coast Guard.)

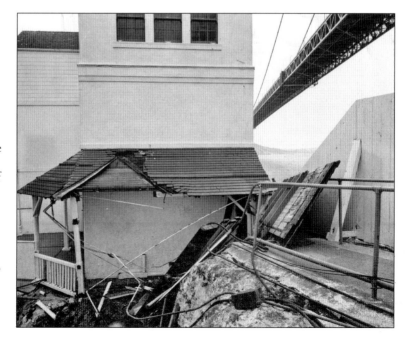

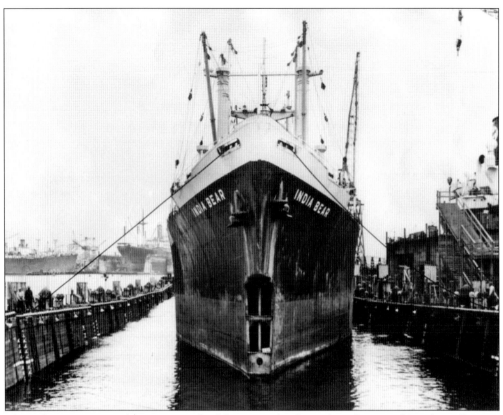

The *India Bear* sustained $60,000 worth of damage to her bow when she veered 200 feet off course and plowed into the Lime Point Lighthouse. (U.S. Coast Guard.)

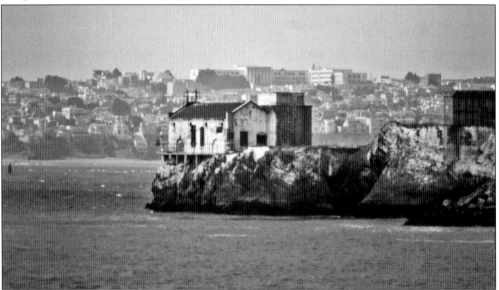

Lime Point is still has an active beacon, although it is now automated. The only building left from the original structure is the fog-signal building, where the current beacon is attached. The building has been badly vandalized and is in poor condition. (John Gaffney.)

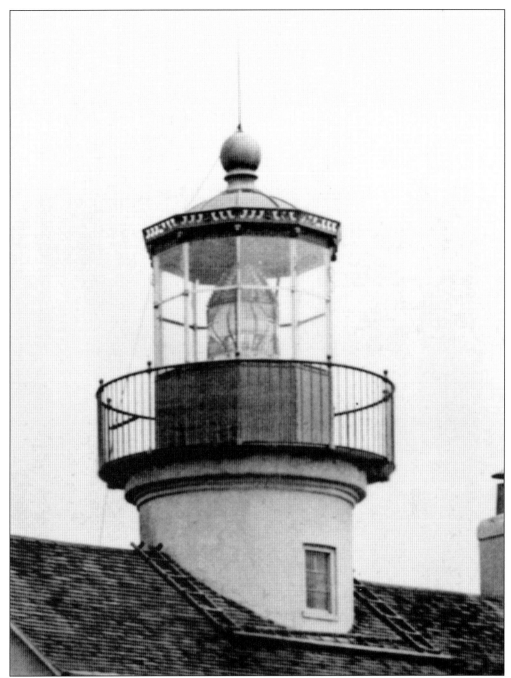

Alcatraz Island held the first lighthouse on the West Coast. The original lighthouse was completed in July 1853. However, instructions were given not to install the Argand lamps and parabolic reflectors that were outlined in the original specifications. The newly developed Lighthouse Board ordered the purchase and installation of the superior Fresnel lens in all new lighthouses. A fixed third-order lens arrived from France and was installed. Head keeper Michael Cassin lit the whale oil lamp for the first time on June 1, 1854, and the beam could be seen for up to 19 miles. (San Francisco Public Library.)

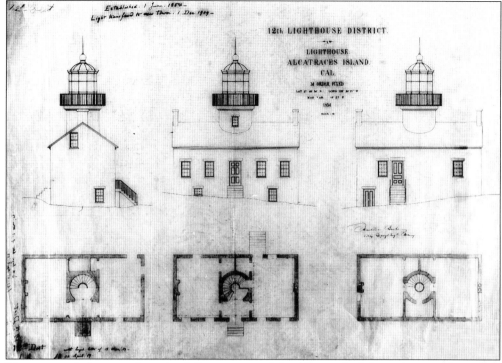

The engineer's drawings show the different views of the Alcatraz Lighthouse's one-and-one-half story Cape Cod–style building. The tower was in the center with a lantern room on top and the living quarters below. (National Archives.)

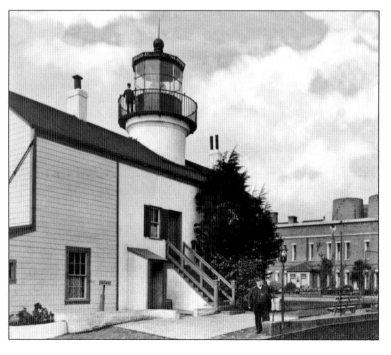

Head keeper Captain Leeds, standing in front of the lighthouse, was the first long-term keeper at Alcatraz. He began his duties in the early 1880s and kept the lighthouse and surrounding grounds in immaculate condition. He also ran a post office that was located in the basement of the lighthouse. The assistant keeps a watch from the lighthouse balcony. (San Francisco Public Library.)

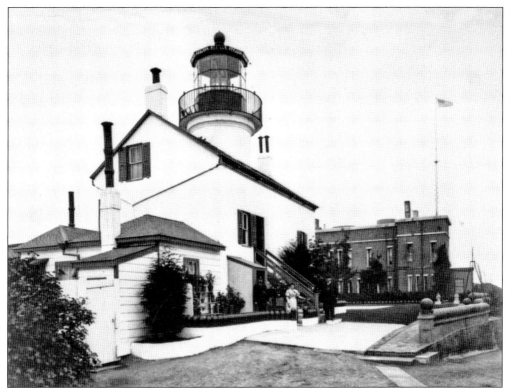

In 1889, Captain Leeds (right), his wife, and the assistant pose in front of the Alcatraz Lighthouse. The Citadel, as the army post was then called, can be seen in the background. (Golden Gate NRA, Park Archives, PAM Negative Collection.)

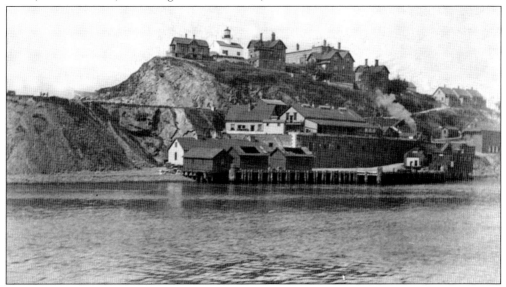

By 1895, Alcatraz Island had become a small city. The inhabitants included the lighthouse personnel as well as officers and soldiers from the army post. For the most part, they all coexisted just fine. A dock was built to provide the island with all the necessities required for the lighthouse and army post. (San Francisco Public Library.)

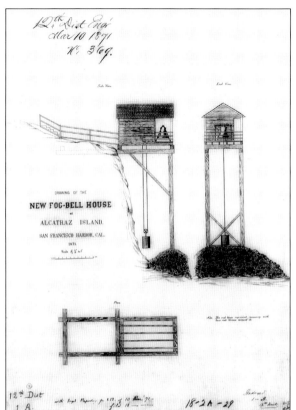

When plans to install a fog bell on the south side of the island were discussed, the War Department insisted on having a say on the location. They did not want the bell to interfere with the guns on the island. This drawing shows the south bell house and the weights to be used to work the mechanical striking machine. (National Archives.)

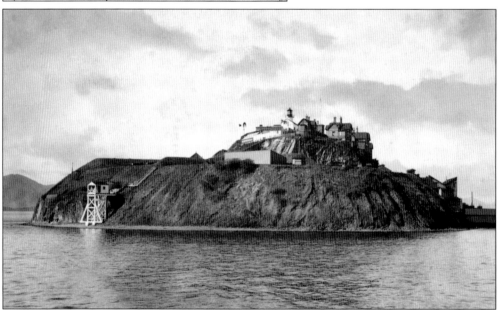

The south side of Alcatraz housed the large bell. The bell was originally struck by hand, many times for hours on end. A mechanical striker was eventually installed. The lighthouse can be seen here perched at the top of the island in 1895. (Golden Gate NRA, Park Archives, Jack Fleming Collection.)

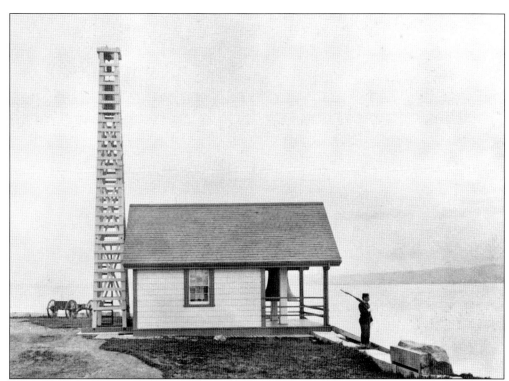

The bell house for the north side of Alcatraz Island was designed differently than the south bell house. The weight to work the striking mechanism was pulled up the tower, as seen here. Army guards kept watch outside the north bell tower, and a cannon can be seen to the left of the building. (U.S. Lighthouse Society.)

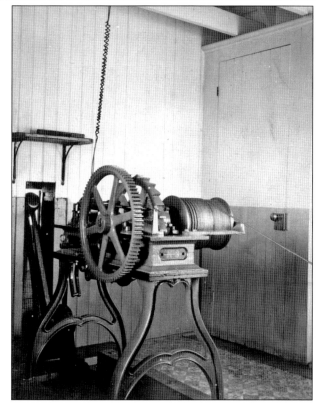

The striking mechanisms for the bells on Alcatraz Island were clock gear–type machines. A weight was either pulled down the hillside at the south bell house or raised up the tower of the north bell house. The lighthouse keepers had to go back and forth between the two bell houses every couple of hours when the fog rolled in to wind the striking mechanisms. (U.S. Lighthouse Society.)

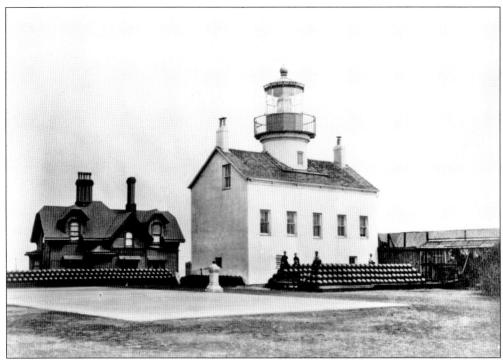

The lighthouse grounds were used as storage for the army's cannon balls. Children, probably from the keepers' families, sit on top of the large stacks. The building to the left is one of the army's senior officer's quarters. (San Francisco Public Library.)

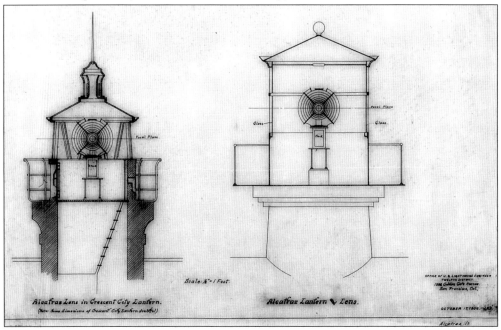

This U.S. Lighthouse Engineers' drawing of the lantern room for the new Alcatraz Lighthouse is dated October 15, 1906. The fourth-order Fresnel lens was to be removed from the original lighthouse and placed in the lantern room of the new tower. (National Archives.)

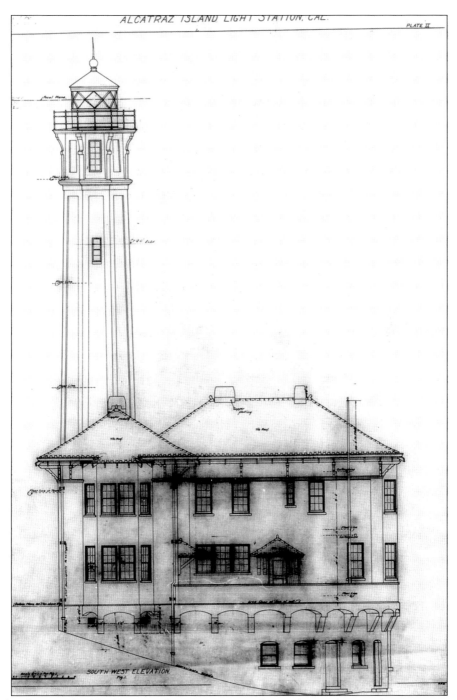

SOUTH WEST ELEVATION.

While Alcatraz Island had been used as a prison since the Civil War, the army began construction of the new federal maximum-security prison in 1909. The prison walls would be taller than the existing lighthouse, so it would have to be relocated. The army wanted to place the beacon over the main door of the prison, but the Lighthouse Board wanted a new tower. This drawing shows the new 84-foot octagon tower and the attached two-and-one-half story living quarters for the keepers. (National Archives.)

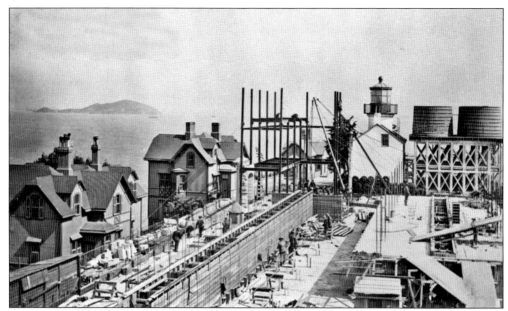

Construction of the new lighthouse and federal prison on Alcatraz Island began in 1909. The start of the scaffolding for the 84-foot tower can be seen just south of the old lighthouse. (Golden Gate NRA, Park Archives, Interpretation Collection.)

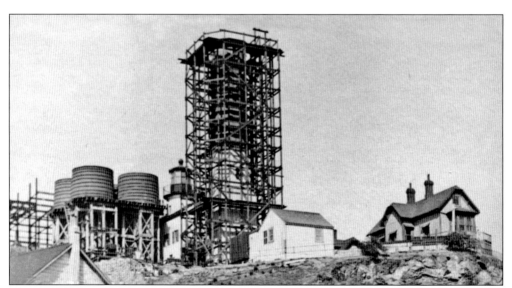

The scaffolding of the new tower dwarfs the original lighthouse. The warden's quarters can be seen on the right. This beautiful old building was soon to be demolished to make room for new buildings. (U.S. Coast Guard.)

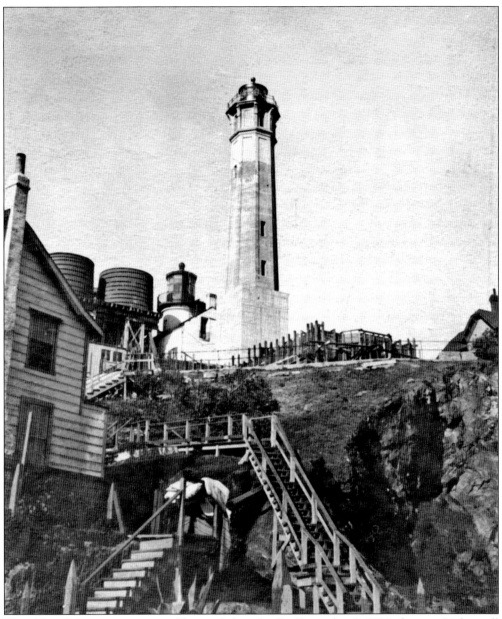

The old and the new are pictured here side by side. On December 9, 1909, the new 84-foot-tall lighthouse on Alcatraz Island was lit for the first time. The old lighthouse sits quietly awaiting its fate—the demolition crew. (U.S. Lighthouse Society.)

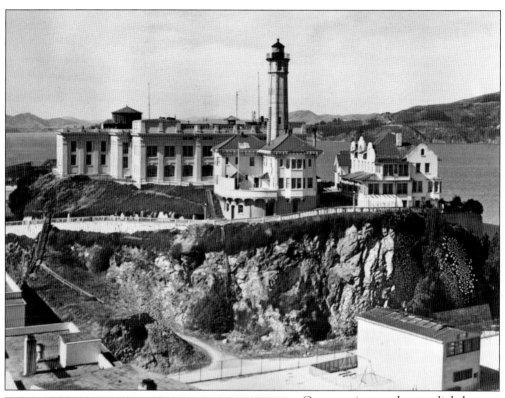

Construction on the new lighthouse, keeper's quarters, and prison are complete. The keeper's quarters are in the building surrounding the lighthouse and can accommodate three families. A swing set for the keepers' and guards' children can be seen next to the building in the foreground. The building to the right is the prison warden's home. (U.S. Coast Guard via Golden Gate NRA, Park Archives, Interpretation Collection.)

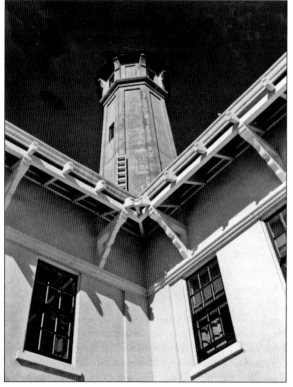

Looking up from the sanctuary of the keepers' quarters' courtyard, one gets the idea of how tall the new tower was. It also shows the detail put into the construction of the building. (U.S. Lighthouse Society.)

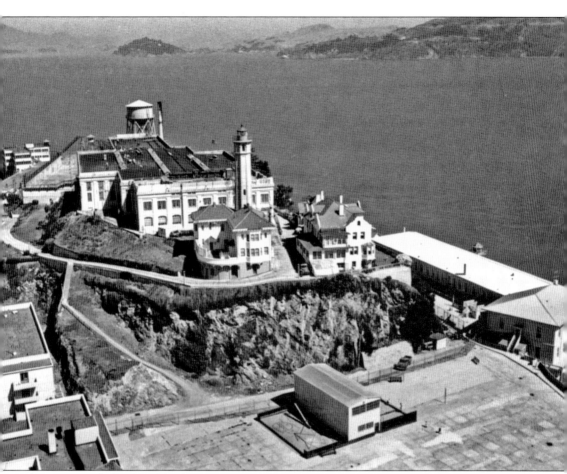

Sharing a small island with high-security prisoners was not an easy task for the lighthouse keepers and their families. They had to follow strict procedures at all times. If there was a problem with the inmates, the keepers were instructed to lock their doors and windows, and stay inside. Fortunately, the way the lighthouse was built, the keepers had access to the tower without having to leave the sanctuary of their homes. The keepers' children had to take a boat to school—the same boat that transported new prisoners to the prison. The wives took the same boat to San Francisco every three weeks for supplies and groceries, most of which had to be frozen to last until the next shopping trip. All on board the boat had to be counted as they got on and again when arriving in San Francisco. Alcatraz Island was a unique experience for the lighthouse keepers and their families. (U.S. Lighthouse Society.)

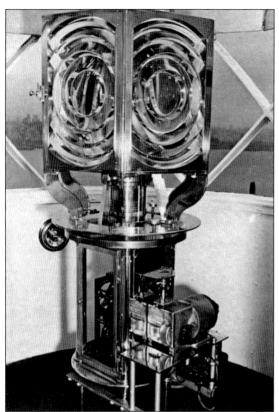

As the San Francisco Bay Area grew, a new light was needed to distinguish the Alcatraz light from the city lights. In 1902, the third-order lens was removed and transferred to Cape Saint Elias Station in Alaska and a revolving fourth-order Fresnel lens with a white flash every five seconds was installed. This 1950s photograph shows the lens transferred from the original lighthouse to the 84-foot lantern room. (U.S. Lighthouse Society.)

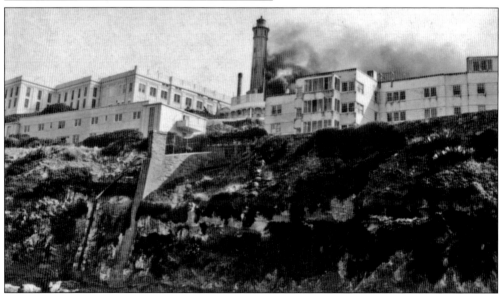

In 1963, the prison was closed, and in November of that year, the lighthouse was automated. The lens was removed and a reflective beacon was installed. On November 9, 1969, Native Americans seized the island and claimed the land as part of the 1868 Sioux Treaty. The occupation lasted until June 11, 1971, when the few remaining people were removed from the island. (U.S. Coast Guard.)

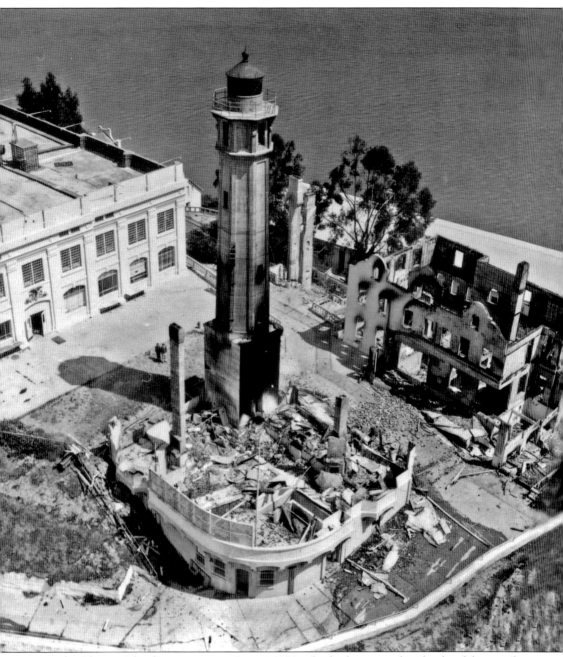

During the Alcatraz Island occupation, on June 1, 1970, a fire broke out on the island and destroyed the keepers' quarters, warden's home, and several other buildings, as well as severely scorching the lighthouse tower. With no fire-fighting equipment on the island, there was no way to put out the fires. (U.S. Coast Guard.)

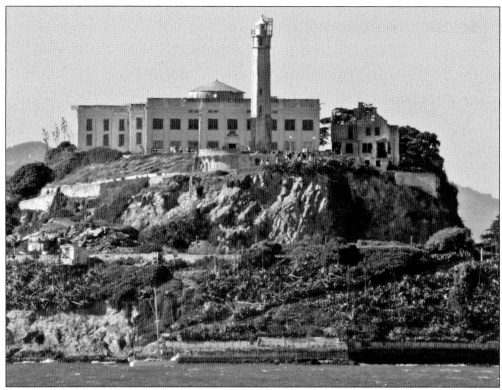

The Alcatraz Lighthouse and prison were slated for demolition until it was turned over to the Golden Gate National Recreation Area. The lighthouse still flashes its beacon every five seconds to warn mariners of the island's dangers. (Nicholas A. Veronico.)

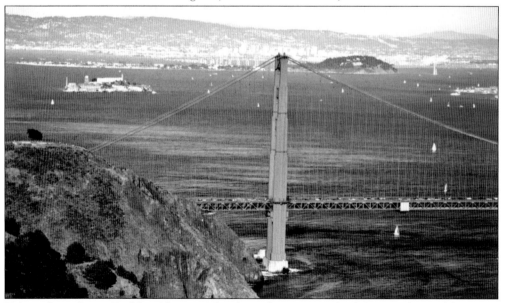

Taken above Point Diablo, Alcatraz Island can be seen to the left over the Golden Gate Bridge, Yerba Buena Island is in the background, and Lime Point is below the bridge's tower. (Nicholas A. Veronico.)

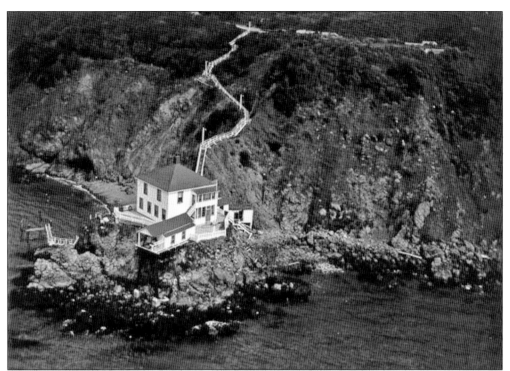

Angel Island is the largest island in the San Francisco Bay. As such, it is also a hazard to navigate with the heavy fog that engulfs the bay. In 1886, a fog bell was finally installed on Angel Island at Point Knox, on the southwest side of the island. Adjacent to the bell house was the keeper's quarters where one man maintained the bell. The only access to the lighthouse was a long, wooden, zigzag stairway down the steep cliff. (U.S. Coast Guard.)

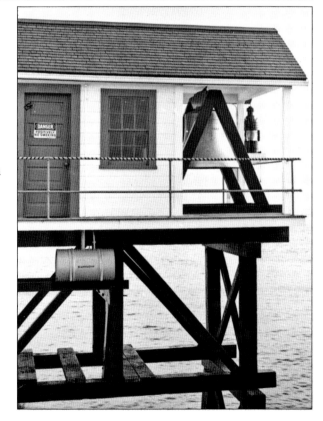

The bell at Point Know was struck by a mechanical sticker that was wound every few hours by the keeper. In November 1900, a fifth-order red lens was added. The light, seen to the right of the bell, was pulled out each night and drawn back into the bell house by pulley during the day to prevent sun damage to the prisms. Many reports state that the bell broke down often and was difficult to wind. (U.S. Coast Guard.)

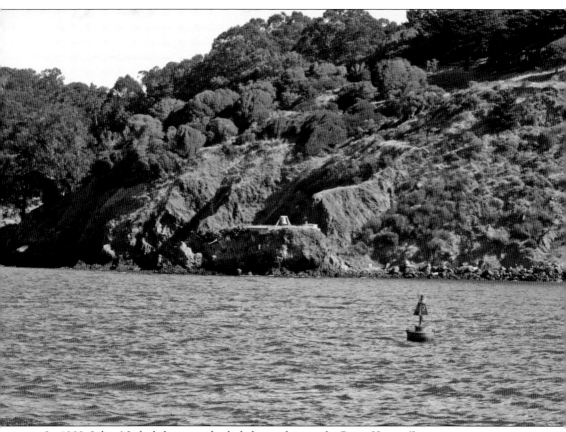

In 1902, Juliet Nichols became the lighthouse keeper for Point Knox. (It was not uncommon to have a woman lighthouse keeper. Her stepmother, Emily Fish, was keeper at Point Piños). On July 2, 1906, the striker mechanism for the fog bell malfunctioned. Using a hammer, Nichols began ringing the bell. The fog did not retreat for 20 hours and 35 minutes, and at no time did Nichols leave her post. Repairs were made to the striker, but again on July 4, 1906, the mechanism failed, and Nichols began ringing the bell with her hammer. She continued throughout the night until the fog lifted again. Nichols retired her post in 1914. The only remains of Point Knox today is the bell. (Nicholas A. Veronico.)

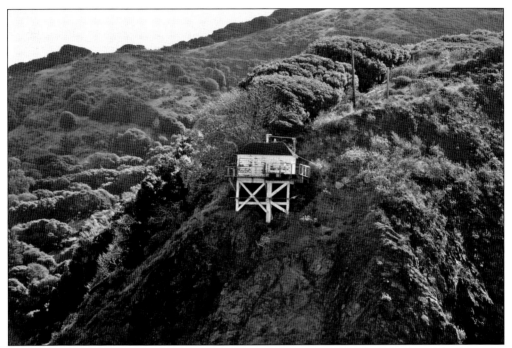

In 1915, on the western tip of Angel Island, a small light was installed in a house built on the hillside at Point Stuart. This light was to be maintained by a second keeper that lived at the Point Knox Lighthouse. (Nicholas A. Veronico.)

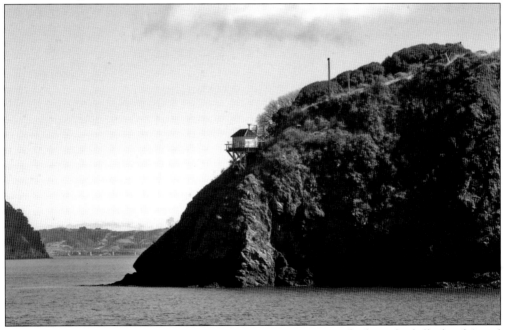

With the addition of the light station at Point Stuart, seen perched on the hillside of Angel Island, manpower on the island increased. This required added living space, so the original one-story keepers' quarters at Point Knox was lifted, and a new story was built beneath it. (Nicholas A. Veronico.)

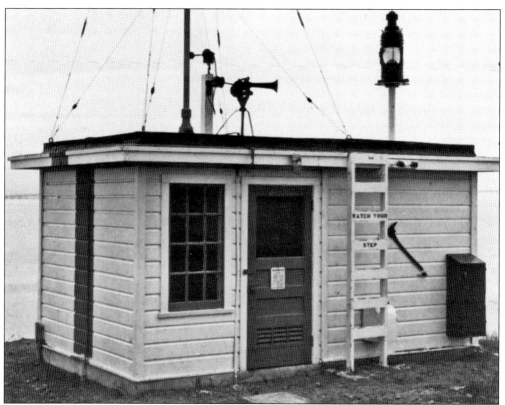

By 1960, the stairs to the Point Knox Lighthouse had become unstable and the living quarters too cramped. The U.S. Coast Guard decided to build new living facilities and a new lighthouse at the southeastern tip of Angel Island at Point Blunt. The structure, like the other lighthouses on Angel Island, was not a traditional lighthouse but a small building with the foghorn and light mounted on the flat roof. A small watchtower was built nearby. (U.S. Coast Guard.)

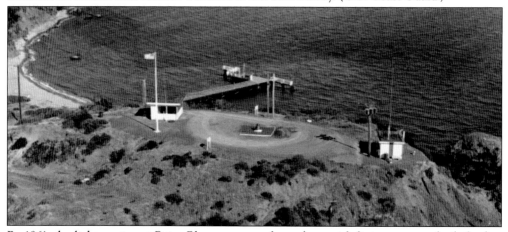

By 1961, the light station at Point Blunt was complete, along with living quarters built further from the point for the keepers and their families. The quarters consisted of four three-bedroom, ranch-style homes. A T-shaped pier was also constructed so supplies could be brought in from the nearby Yerba Buena Depot. In 1963, the old lighthouse at Point Knox was considered unnecessary, so the U.S. Coast Guard burned it down. (U.S. Coast Guard.)

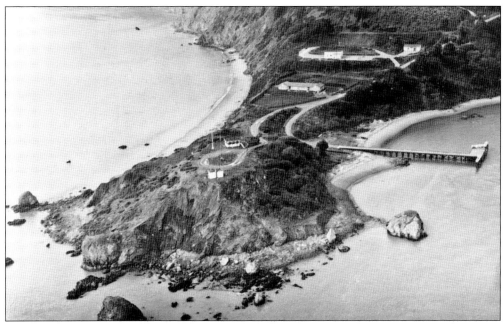

On June 28, 1976, the Point Blunt Lighthouse became the last manned lighthouse on the West Coast. The flat-roofed lighthouse was torn down and a green light and fog signal were automated and attached to the watch room. Point Blunt remains an active Coast Guard Station. (U.S. Coast Guard.)

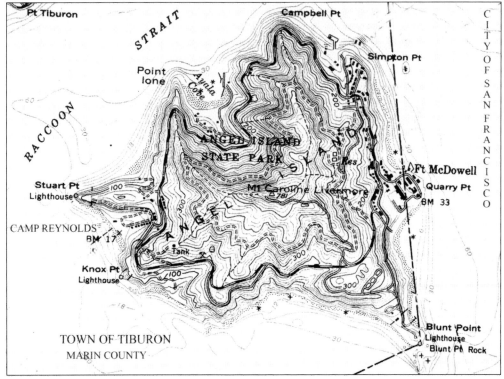

This topographical map outlines the location of each of the three lighthouses that were once part of the Angel Island landscape—Point Knox, Point Stuart, and Point Blunt. (U.S. Geological Survey)

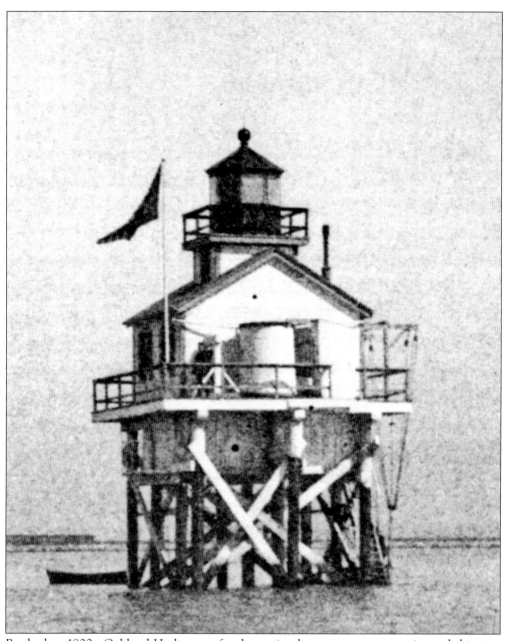

By the late 1800s, Oakland Harbor was fast becoming known as a transcontinental shipping terminal. With that came the need for additional aids-to-navigation and the Lighthouse Board appropriated $5,000 for a lighthouse and fog signal. On January 27, 1890, a light in a little cottage on stilts lit the harbor for the first time. It had a fifth-order lens and used a 3,500-pound bell as its fog signal. (U.S. Coast Guard.)

Four

SOUTH BAY SENTINELS
OAKLAND HARBOR AND
YERBA BUENA ISLAND

As San Francisco Bay became a world-class port, Oakland Harbor, to the south in the bay, was becoming a transcontinental shipping terminal. By the 1880s, ships were delivering goods made in faraway, exotic lands. Oakland Harbor was known as an efficient port and proved it yet again with the construction of the lighthouse. The bidding process was started in July 1889, and the project was complete by November of that year. The small cottage with the lantern room atop, situated on pilings 240 feet from the jetty, began service on January 27, 1890.

One requirement to become a keeper at the Oakland Harbor Lighthouse was the ability to row a boat. With the lighthouse being completely surrounded by water, the keepers had to take a rowboat for all off-site tasks, including picking up mail and supplies from town. The Wickies not only maintained the light and fog bell at the station, but they also maintained the south jetty light across the estuary and the red lantern in the bay a mile to the east.

By the early 1900s, the pilings the small Oakland Harbor Lighthouse sat on became unstable. Small, underwater, wood-boring creatures similar to termites, called teredos, had all but eaten away the pilings. Measures were taken to shore up the pilings, but by 1902, it was obvious that a new lighthouse would need to be constructed. Large concrete-filled pilings were installed with a deck of steel beams to house a new lighthouse. The new beacon began operation on July 11, 1903. The Oakland Harbor Lighthouse remained in service until 1966, when it was sold, moved, and converted to a restaurant.

The other sentinel of the south bay is the Yerba Buena Lighthouse. Here a fog bell and lighthouse were located on the south side of Yerba Buena Island, also known as Goat Island. The bell was installed in 1874, and the lighthouse followed in 1875.

Yerba Buena Island was also home to the 12th Lighthouse District Depot, which was also the West Coast headquarters for the U.S. Lighthouse Service. The depot was the main port for the lighthouse tenders that serviced and provided supplies to all lighthouses along the West Coast. Also, when buoys or beacons could not be serviced at sea, they were brought to the depot for repairs. The depot played a vital roll in keeping all of the West Coast lighthouses and aids-to-navigation running smoothly.

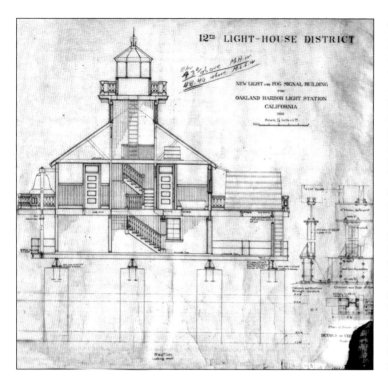

The original Oakland Harbor Lighthouse sat on wooden pillars in water approximately 13 feet deep. Teredos, underwater worms that eat wood, had taken their toll on the pillars, leaving the structure in danger of collapse. This original 1902 architect's drawing of the second Oakland Harbor Lighthouse shows a cutaway of the building, outlining the 4-foot-thick pillars the new two-story structure would sit on, the interior stairway to the lantern room, and the support for the large fog bell. (National Archives.)

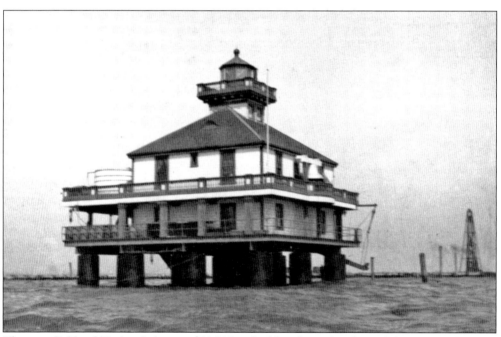

The new Oakland Harbor light cost $19,000 to build and was first lit on July 11, 1903. It was a beautiful, white, two-story structure with wraparound balconies on both levels and a red roof. The black, iron, lantern room held a white, fixed, fifth-order lens that flashed every five seconds. (U.S. Coast Guard.)

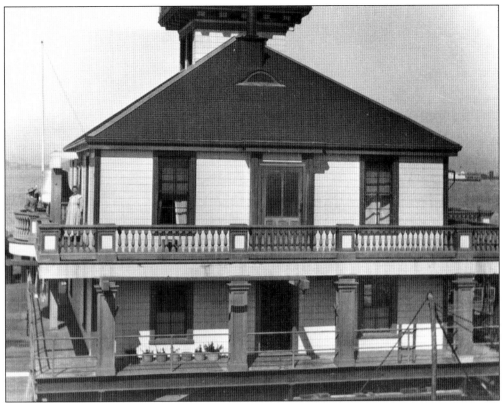

The second-story balcony held a 3,500-pound bell with a mechanical striker that rang every five seconds when the fog rolled in. Note the size of the bell compared to the two women standing on either side of it. (U.S. Lighthouse Society.)

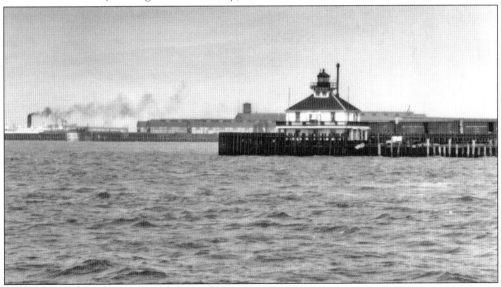

Once isolated in the waters of the Oakland Harbor 240 feet from the jetty, the lighthouse soon merged with the city. The Western Pacific Railroad built its ferry landing completely around the lighthouse. Looking closely, railcars can be seen beside the lighthouse. (U.S. Lighthouse Society.)

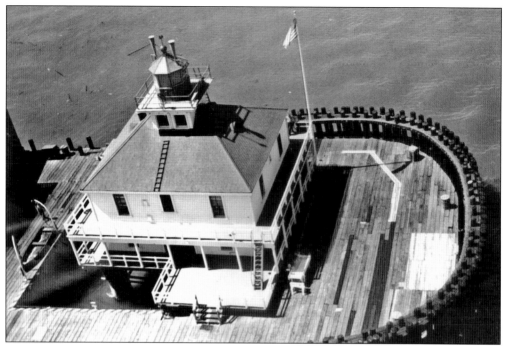

In 1918, the fog bell was replaced with an air diaphone that gave a two-second blast every 15 seconds. The twin horns can be seen rising above the lantern room. (U.S. Lighthouse Society.)

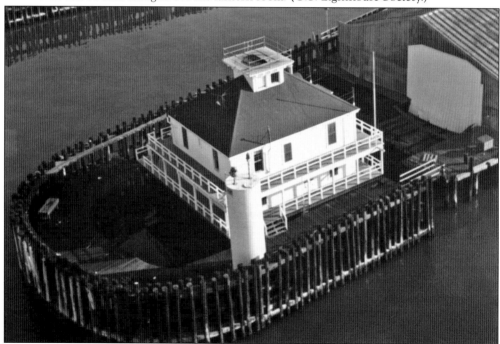

By 1966, the Oakland Harbor Lighthouse had outlived its usefulness. An automatic beacon was installed on the top of a tank in front of the station, and its magnificent fifth-order lens was extinguished for the last time. The lantern room, already missing in this photograph, was moved to the Mark Abbott Memorial Lighthouse in Santa Cruz. (U.S. Lighthouse Society.)

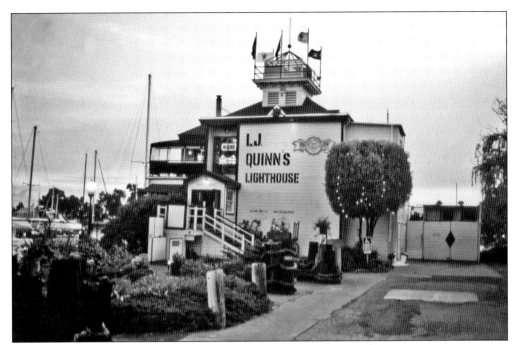

With the lighthouse no longer necessary, the structure was sold for $1. The cost to move it six miles to Embarcadero Cove set the new owner back $22,144. It now sits at 1951 Embarcadero East in Oakland's Embarcadero Cove Marina and is home to Quinn's Lighthouse Restaurant and Pub. (John Gaffney.)

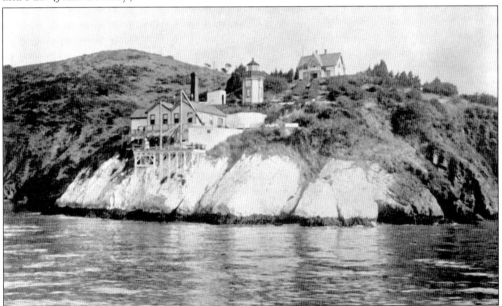

Despite its prominent location halfway between San Francisco and Oakland, the Yerba Buena Lighthouse received many "hand-me-downs" from other light stations. In 1874, a fog bell from Point Conception was installed on the south end of the island. By 1875, a small lighthouse was built next to the bell on a 50-foot cliff overlooking the bay. The fifth-order lens came from Yaquina Bay, Oregon. (Library of Congress.)

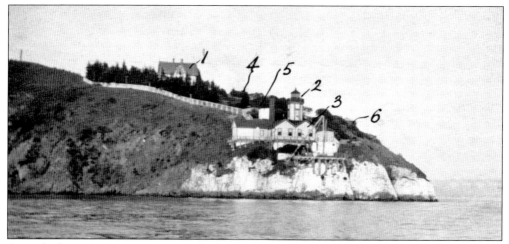

Several other support structures were built around the Yerba Buena Lighthouse. Outlined in this January 1908 photograph are: 1) a beautiful Victorian Gothic home built for two keepers and their families, 2) the lighthouse tower, 3) the twin fog-signal buildings, each housing 10-inch steam whistles, 4) the tool house, 5) the oil house, and 6) the oil tanks. (U.S. Lighthouse Society.)

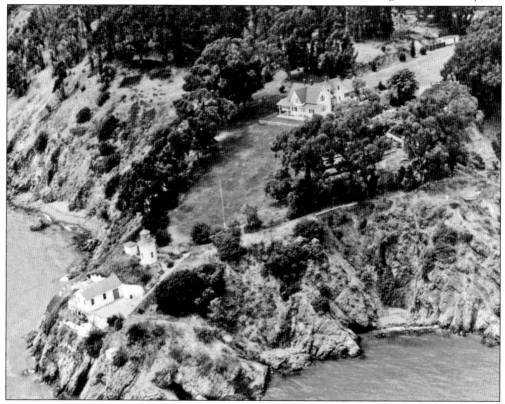

Yerba Buena Island has had many names over the years, including Goat Island when gold prospectors settled in the area and used the island as grazing land for their goats. The goats and loggers removed most of the trees and vegetation on the island. On November 27, 1886, California's first Arbor Day was celebrated by replanting Yerba Buena Island. The trees surrounding the keepers' quarters today are a result of this planting. (U.S. Lighthouse Society.)

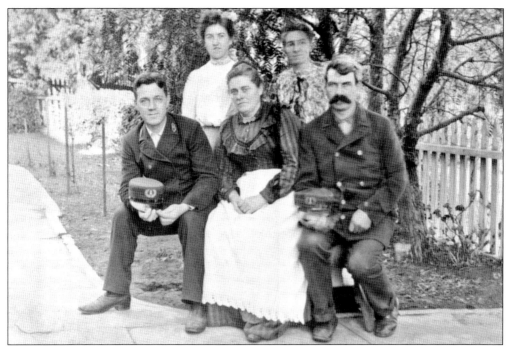

Yerba Buena station was a particular favorite with families because of its proximity and ease of availability to San Francisco and Oakland. Keeper John Kofod (seated right) served two tours on Yerba Buena Island—first as assistant from 1903 to 1914, when he transferred to East Brother Light, then returned as head keeper in 1921 until his retirement in 1929. (U.S. Lighthouse Society.)

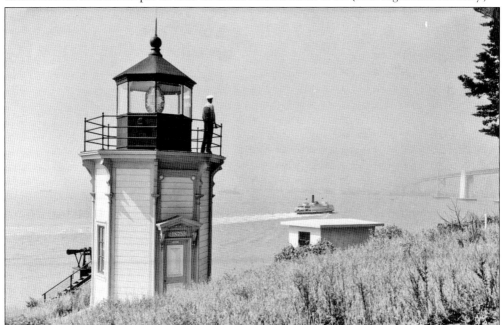

A keeper stands lookout on the deck of the 20-foot-tall Yerba Buena Lighthouse overlooking the bay as one of the ferryboats passes by the island. The fixed, white, fifth-order lens can be seen for 14 miles. (U.S. Lighthouse Society.)

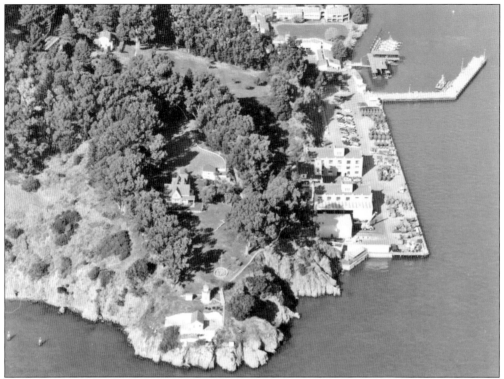

In 1873, the 12th Lighthouse District moved the Lighthouse Depot from Mare Island to Yerba Buena Island. It was located on the south side of the island just around the point from the lighthouse. (U.S. Lighthouse Society.)

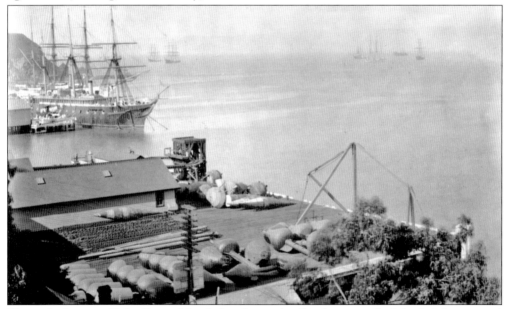

The early depot on Yerba Buena Island played a vital roll in keeping all of the lighthouses and lightships up and down the California coast supplied and their equipment serviced properly, as well as maintaining the numerous buoys along the coast. (U.S. Lighthouse Society.)

The depot was expanded to accommodate the endless parade of ships loading supplies or in need of servicing. Several tenders called Yerba Buena Island home, including the *Madrono*, which was put into service in 1885. By 1890, the *Madrono* was making a minimum of four runs a year to each of the West Coast's 28 light stations. Hundreds of hours were spent by her crew of 26 delivering supplies to light stations and repairing buoys. (U. S. Coast Guard.)

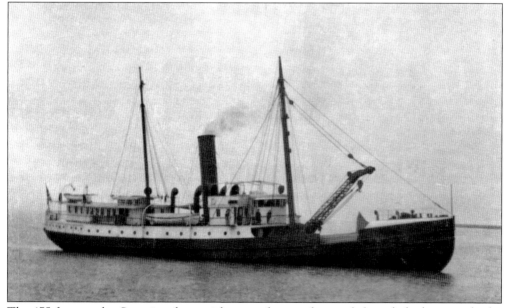

The 175-foot tender *Sequoia*, along with two other tenders and three lightships, made the 14,000-mile trek from their birthplace in Camden New Jersey, to San Francisco. As the other ships continued on to their assigned stations, Yerba Buena Island became home to the *Sequoia*. (U.S. Coast Guard.)

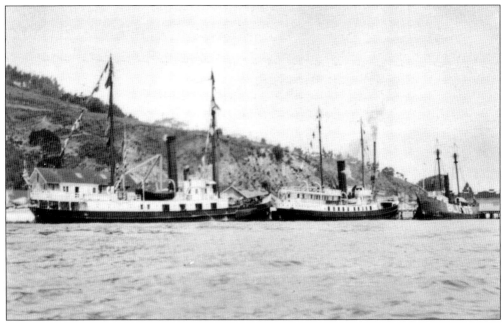

Tasked with servicing all of the navigational aids along the California coast, Yerba Buena Island was a busy depot with as many as three or four vessels docked at one time. On July 4, 1922, the *Sequoia*, the *Madrono*, and the *Blunts* (LV 83) were all docked at the depot. (U.S. Lighthouse Society.)

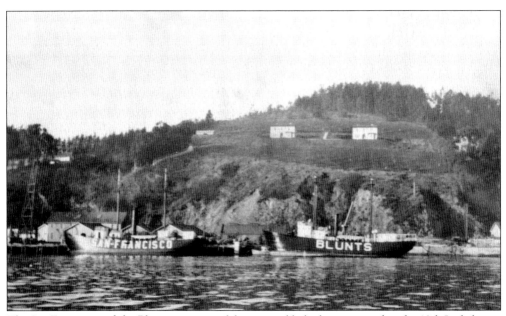

The *San Francisco* and the *Blunts* were two of the original lightships assigned to the 12th Lighthouse District and stationed at the Yerba Buena Depot. Both the *San Francisco* and the *Blunts* were docked at the depot on July 7, 1930. It was unusual for two lightships to be in port at the same time, but it was occasionally required due to maintenance issues. (U.S. Lighthouse Society.)

Lenses and lighted buoys throughout the 12th district were repaired and maintained at Yerba Buena Depot's Lamp House. The depot also housed a keeper, blacksmith, blacksmith's assistant, and watchman. The tender's crew also worked at the depot when they were in port. (U.S. Coast Guard.)

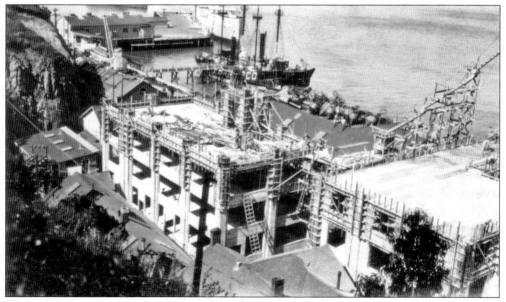

The Yerba Buena Depot outgrew its small facilities, and a new, larger depot was planned. By May 1930, construction was well underway on the new buildings. Lightship *San Francisco* can be seen tied at the dock behind the construction. (U.S. Lighthouse Society.)

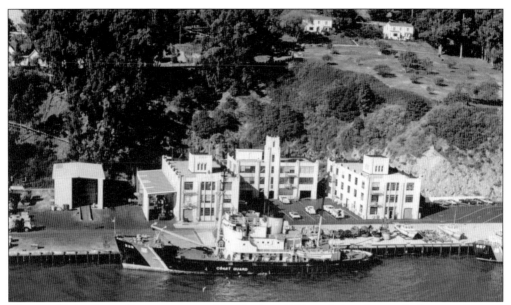

The new Yerba Buena Depot was completed by late 1930, and ships began docking at the new facility. (U.S. Lighthouse Society.)

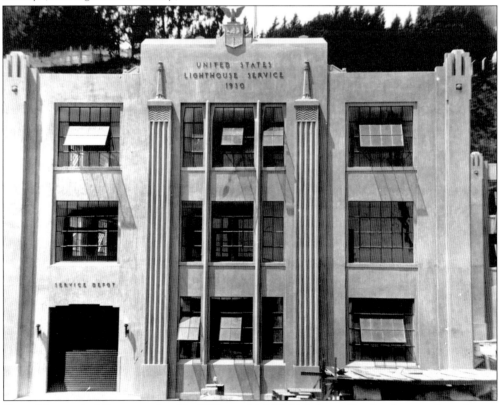

One of the new buildings completed in 1930 was this U.S. Lighthouse Service depot and warehouse. Workers at the depot were all employees of the U.S. Lighthouse Service until the U.S. Coast Guard took over the duties in 1939. (U.S. Lighthouse Society.)

In 1933, construction of the San Francisco–Oakland Bay Bridge was underway. A tunnel was bored through Yerba Buena Island, connecting the east and west sections of the bridge. The east section can be seen to the right of the lighthouse. (Nicholas A. Veronico.)

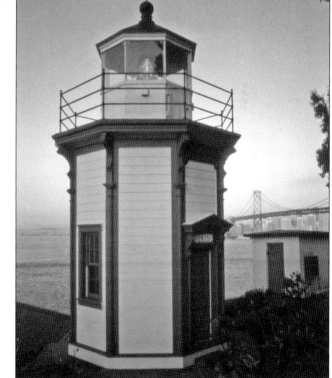

The Yerba Buena Lighthouse is still an active aid-to-navigation; the light was automated in 1958. Floodlights were added to make the lighthouse more visible and distinguish it from the city lights. The west span of the Bay Bridge and the San Francisco skyline can be seen over the flat roof of the old oil house. (John Gaffney.)

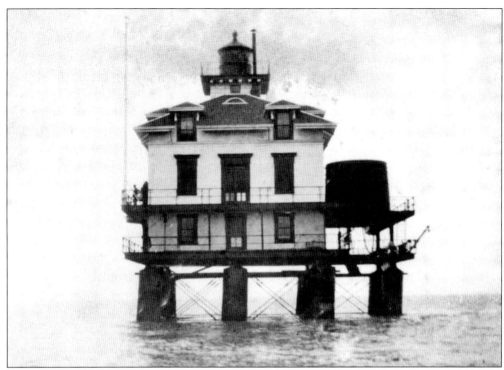

The Southampton Shoal Lighthouse, seen here in 1913, was a beautiful, three-story, Victorian structure completed in 1905. It was built on 11 metal pilings in the shipping channel, with Berkeley to the east and Angel Island and Tiburon to the west. (Richmond Museum of History.)

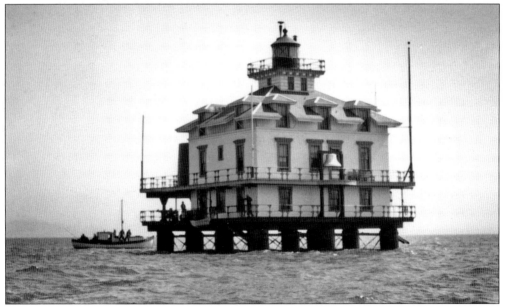

The lantern room housed a fifth-order Fresnel lens, and a fog bell was positioned on the second-story balcony. The large water tank collected fresh water from the roof, so controlling the gulls became a challenge. A small boat was used by the keepers to go to Point Richmond to pick up supplies and mail. (U.S. Lighthouse Society.)

Five

STRAITS OF THE BAY
SOUTHAMPTON SHOAL,
EAST BROTHER ISLAND, MARE ISLAND,
CARQUINEZ STRAITS, AND ROE ISLAND

After passing through the Golden Gate and maneuvering through the San Francisco Bay, ships heading north toward Sacramento needed beacons and fog signals to guide their way. The first of the sentinels passed was Southampton Shoal. Completed in 1905, the three-story Victorian beauty sat atop pilings between Berkeley and Angel Island.

Entering San Pablo Bay requires ships to navigate through a narrow channel only 2 miles wide. This area, often shrouded in thick fog, has two groups of islands that rise above the waves—the East and West Brothers and the smaller East and West Sisters. After a lengthy battle with landowners at Point San Pablo, the largest island, East Brother, was chosen for the location of a lighthouse. In 1874, East Brother Lighthouse's beacon was lit to guide passing ships though the narrow channel.

Exiting San Pablo Bay to the east sits Mare Island, home to the former Mare Island naval base and shipyard. With the heavy military and civilian ship traffic in the area, a marker beacon was no longer sufficient. The Mare Island Lighthouse was completed in 1873 and was manned until 1917. The Carquinez Strait Lighthouse was built across the narrow strip of water from Mare Island. Completed in 1910, the Carquinez Strait Lighthouse was a beautiful, 28-room, Victorian building with the lighthouse in the center and the keeper's quarters surrounding it. The Carquinez Strait Lighthouse was staffed until 1951.

Traveling up the strait into Suisun Bay, ships navigating to Stockton and Sacramento would encounter Roe Island, the last lighthouse of the San Francisco Bay Area. This lighthouse, completed in 1891, sat at the east end of Suisun Bay, across the channel from the Port Chicago Naval Magazine, which would ultimately be the demise of the Roe Island Lighthouse. The five beacons in the straits of the bay were all completed by 1905 in the beautiful Victorian-style architecture that dominated the area's lighthouses.

More than 155 years after the first lighthouse was lit on the West Coast of the United States, modern technology has automated all of these important aids-to-navigation. While some of the lighthouses have been preserved, many are only memories, their images visible only on the printed page.

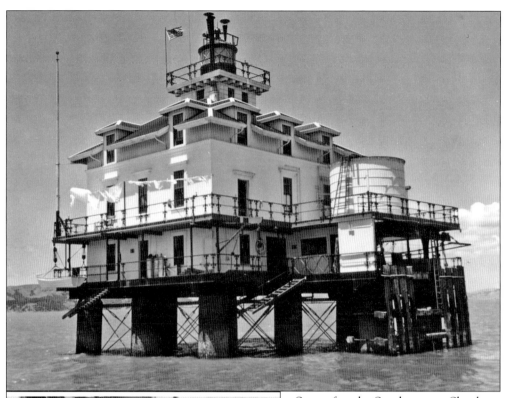

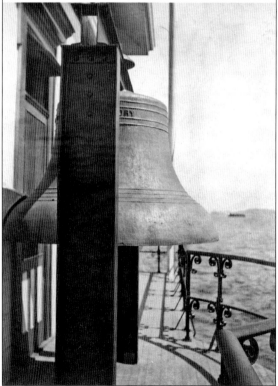

Soon after the Southampton Shoal Lighthouse began service, it almost fell into the bay when erosion of the shoal nearly undermined the support columns. Several tons of rock were brought in and piled around the columns. Then the earthquake of 1906 caused the support columns and house to tilt almost 11 degrees. The structure and most of the columns were straightened, and the columns filled with concrete; however, some of them remain tilted. (U.S. Coast Guard.)

The fog bell of the Southampton Shoal Lighthouse weighed 3,000 pounds and was mechanically struck when the fog rolled in. When the U.S. Coast Guard took control of the lighthouse in 1939, the bell was replaced by two diaphone horns attached to the lantern room. (U.S. Lighthouse Society.)

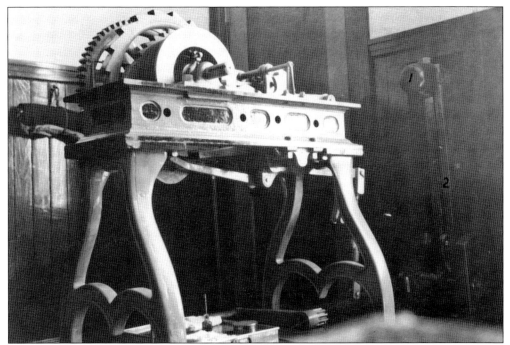

The bell striking mechanism was a Gamewell Bell Striker that worked similar to a clock's mechanism. The weight was wound periodically by the keeper, and as it unwound, it would strike the bell at specific intervals through a hole in the wall. (U.S. Lighthouse Society.)

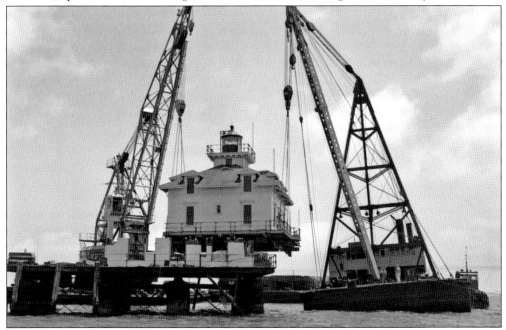

In 1960, the Southampton Shoal light was doused for the last time, and the top two stories of the building were lifted by cranes and placed on a barge. The building was tugged to Tinsley Island on the San Joaquin River and is now used as an inn by the St. Francis Yacht Club. (U.S. Lighthouse Society.)

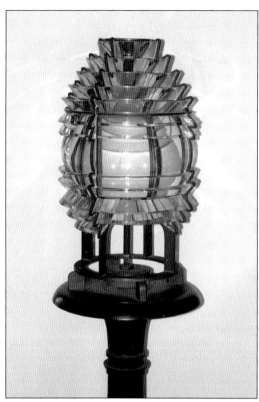

The fifth-order Fresnel lens of the Southampton Shoal Lighthouse was salvaged and is on display at the museum on Angel Island. (Nicholas A. Veronico.)

Today all that remains of the Southampton Shoal Lighthouse are a few pilings. A concrete platform was constructed to house a red, automated beacon. (U.S. Lighthouse Society.)

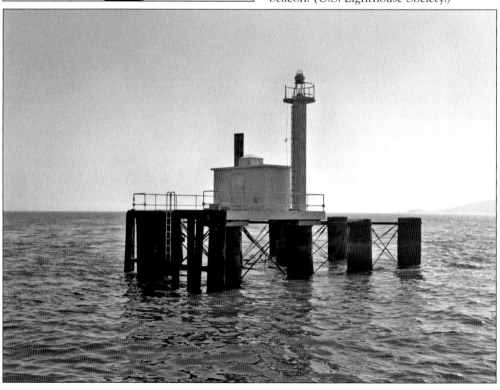

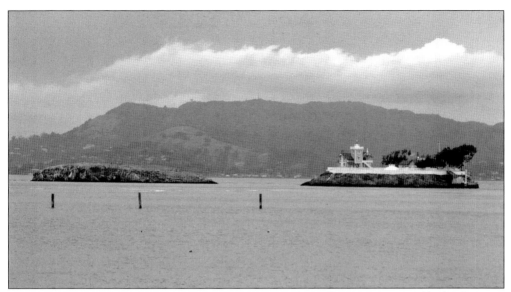

Rising at the mouth of San Pablo Bay, just 1,000 feet from shore, are two small islands—East Brother and West Brother. Ships traveling from the San Francisco Bay toward Sacramento pass through this 2-mile-wide strait. As vessel traffic increased, funds for a lighthouse at Point San Pablo were allocated by Congress in 1871. After land disputes on Point San Pablo, East Brother Island was finally chosen as the location of the lighthouse, and construction began in May 1873. (Nicholas A. Veronico.)

The top of East Brother Island was blasted level to accommodate the new structures. These drawings show the two-story, Victorian keepers' quarters with an attached three-story lighthouse tower. To give additional strength to the building and provide some insulation from the sound of the foghorn, the outer walls of the building were filled with brick and mortar. (National Archives.)

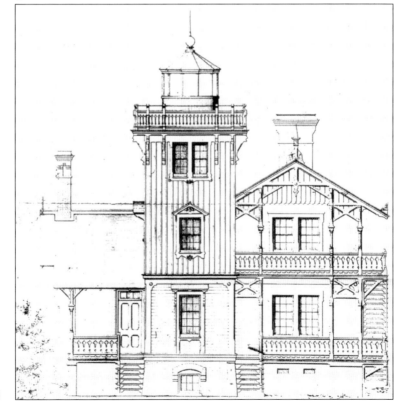

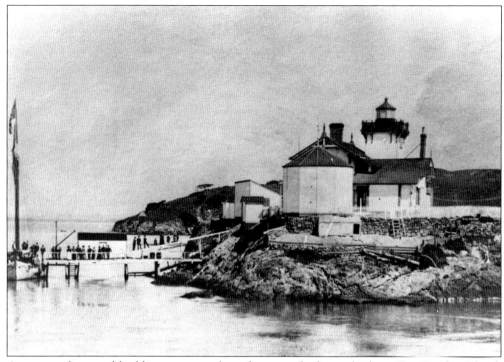

A separate fog-signal building, water tank, and storage shed were built on East Brother Island. On the north side of the island, a wharf was also constructed, and a large, domed cistern was installed in the center of the island. (Richmond Museum of History.)

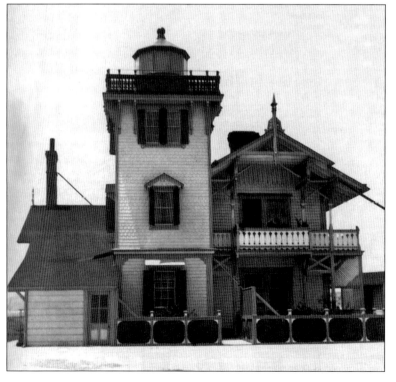

East Brother originally housed a rotating fourth-order Fresnel lens that lit the strait for the first time on March 1, 1874. In 1880, the Lighthouse Board decided to replace the rotating lens with a fixed fourth-order lens. The connected house had three rooms per story to accommodate the three keepers and their families. Cooking was done in a common kitchen to the left of the tower. (U.S. Lighthouse Society.)

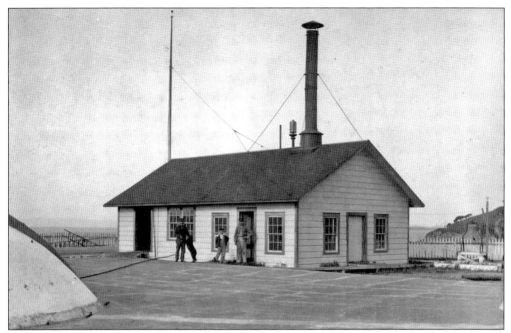

The fog-signal building was on the east side of East Brother Island. It housed a steam-powered mechanism that sent an alternating four-then-eight-second blast every 24 seconds. The 10-inch whistle can be seen to the left of the smokestack. (Richmond Museum of History.)

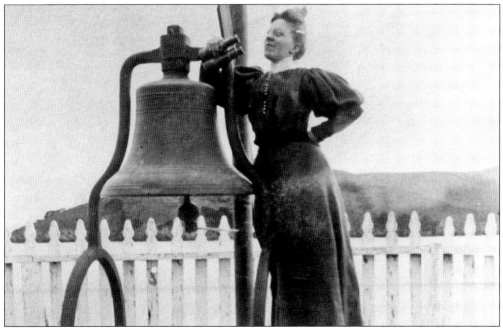

When the fog rolled in within two miles of East Brother, the boiler for the steam whistle was started. While waiting for the boiler to produce enough steam to blow the whistle, sometimes as long as 45 minutes, the fog bell, installed in 1878, was rung by hand every 15 seconds. Breta Stenmark, known as the "Bell Lady," is shown keeping watch over the straits, c. 1941. (Richmond Museum of History.)

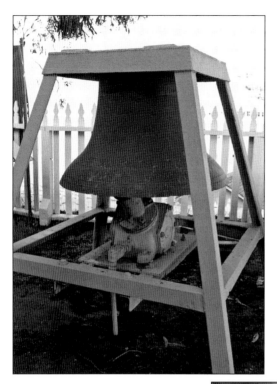

In 1907, the job of ringing the fog bell manually was replaced with a mechanical striking mechanism. (Nicholas A. Veronico.)

Swedish immigrant John Stenmark joined the U.S. Lighthouse Service in 1888. While working aboard the lighthouse tender *Madrono*, Stenmark saved lighthouse inspector Thomas Perry from drowning. As the reward for his actions, Stenmark was appointed assistant keeper at Año Nuevo on August 1, 1890, and eventually rose to head keeper. In 1894, Stenmark, his wife, Breta, and their first child Annie were transferred to East Brother, where they remained until his retirement in 1914. (Richmond Museum of History.)

The Stenmarks adapted well to their small lighthouse island. They had four children: two girls, Annie and Ruby, shown here, and two boys, Phillip and Folke. Stenmark had to row across the strait to Point San Quentin to get a doctor for the birth of the three children born on the island. A live-in teacher was provided for the children until roads were built to nearby Point San Pablo. The children then began attending school there. (Richmond Museum of History.)

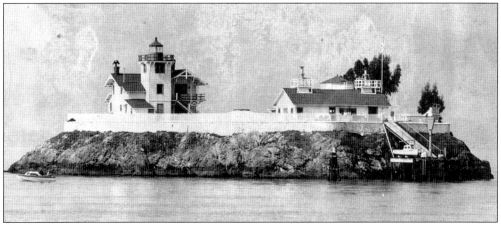

Storms severely damaged the East Brother wharf in 1875 and again in 1880; both times the wharf was repaired. Teredos, underwater termite-like creatures, took a final toll on the wharf in 1894, and it was declared unsafe, so a new wharf was built. By 1903, the wharf was again declared unsafe. This time the north wharf was abandoned, and a new one was built on the east side of the island, where it is located today. (Richmond Museum of History.)

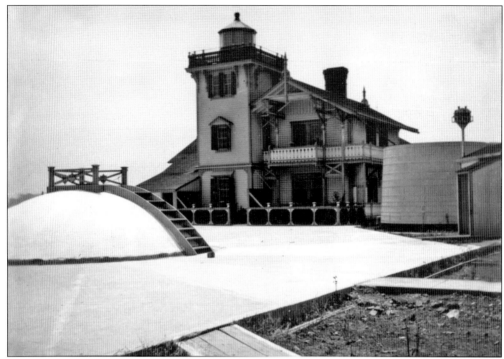

To collect fresh water for the fog signal and domestic use, most of the area in front of the lighthouse was covered with concrete. When it rained, the wooden plugs were removed from the trough around the cistern, and it would fill with the rainwater. In early 1906, new concrete for the rain shed was poured to replace the original laid in 1882. (Richmond Museum of History.)

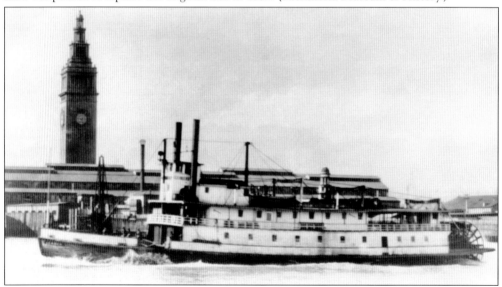

At 2:30 a.m. on the morning of June 13, 1907, the little island of East Brother shook. The steamer *A. C. Freese*, towing the steamer *Leader* and two barges, approached the island from the north. As they passed, the *Leader* was caught by the currents and struck the island's wharf. The crew of the *Leader* admitted that they were asleep while in tow. Repairs for the damage to the wharf cost $1,600. (Richard Wheeler Collection.)

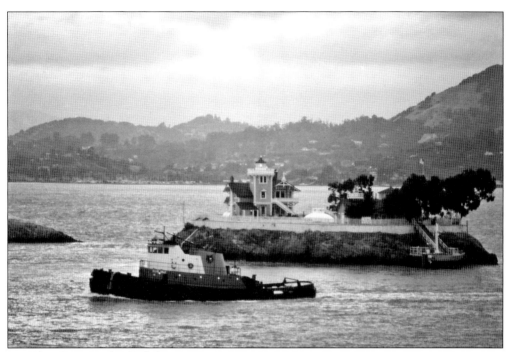

On July 25, 1914, John Kofod became head keeper at East Brother Lighthouse; he transferred to Yerba Buena Island in 1921. Keeper Willard Miller began his service at East Brother Lighthouse in 1922. Like John Stenmark, Miller's duties at the station lasted 20 years. (John Gaffney.)

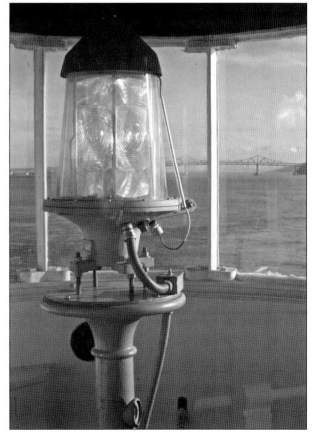

Electricity came to East Brother in 1934, when a cable was run between the island and Point San Pablo. Both the home and fog-signal apparatus were wired, and the fixed fourth-order lens was replaced with a rotating fifth-order lens. In 1969, the lighthouse was fully automated. This small lens is currently installed in the lantern room. The Richmond–San Rafael Bridge can be seen in the background. (Nicholas A. Veronico.)

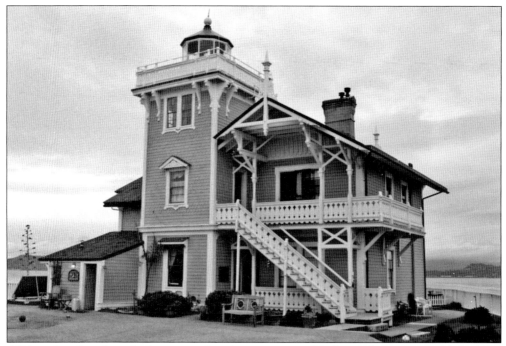

All but abandoned, and after years of neglect, a group of Richmond citizens established the nonprofit East Brother Light Station, Inc. The group has restored the lighthouse and many of the buildings. The U.S. Coast Guard granted the group a 20-year, no cost, renewable license in July 1979. (Nicholas A. Veronico.)

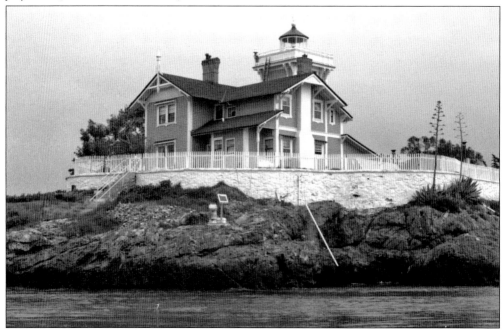

The East Brother Island Light Station was listed on National Register of Historic Places, No. 71000138, in 1993. Today the nonprofit organization runs a bed-and-breakfast on the island. Proceeds go toward continued maintenance of this historical site. (Nicholas A. Veronico.)

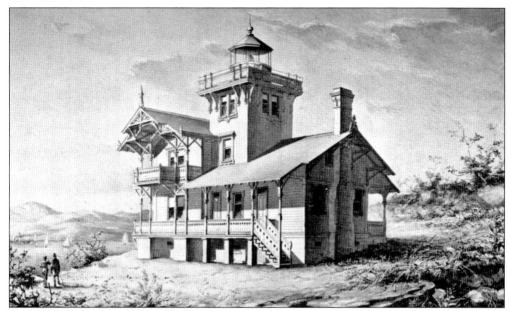

The Mare Island Lighthouse sat at the point of Mare Island adjacent to Vallejo, about 23 miles north of San Francisco. The Napa River enters the Carquinez Straits on the east side with San Pablo Bay to the west. This 1872 sketch shows the beautiful structure that would be both the keepers' quarters and lighthouse. Completed in 1873 to replace the marker beacon, the lantern tower housed a fixed, white, fourth-order Fresnel lens. (Library of Congress.)

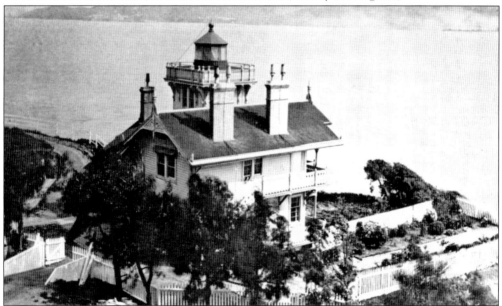

The lighthouse and grounds were meticulously kept from 1881 until 1916 by Kate McDougal. McDougal's husband, Charles, who was the inspector of the 12th Lighthouse District, drowned when his small boat capsized. It is believed that he was weighted down by the gold he was delivering as payroll to the Cape Mendocino light. She was left with four young children and a $50 per month pension. Navy friends of McDougal arranged her appointment as keeper of the Mare Island Lighthouse. (U.S. Coast Guard.)

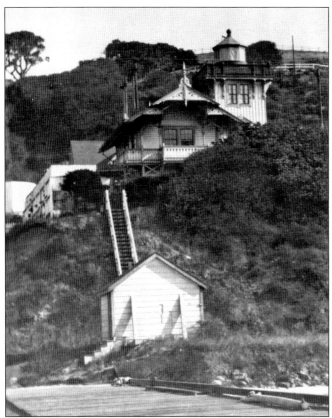

Looking up from the pier, one can see the drapes pulled closed in the lantern room of the Mare Island Lighthouse. This was standard practice to keep the sun from discoloring the prisms and to prevent the sun hitting the magnifying bull's-eyes and stating a fire. (U.S. Coast Guard.)

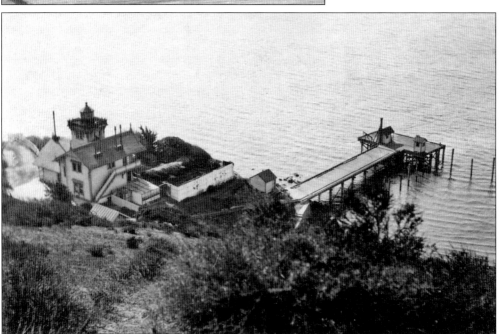

The Mare Island station had a T-shaped pier with two small structures. The small structure with the tower (left) housed the fog bell. The other building housed the tide gauge. (U.S. Coast Guard.)

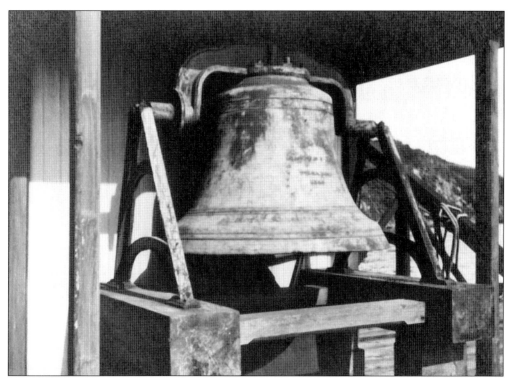

The fog bell is one of the only remnants of the Mare Island Lighthouse. The fog bell was automated in 1916 and still rings to this day. Kate McDougal retired the same year. (U.S. Coast Guard.)

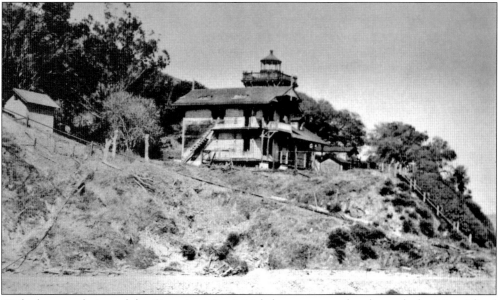

With the completion of the Carquinez Strait Lighthouse across the channel, the Mare Island Lighthouse was considered unnecessary. The Mare Island Lighthouse was abandoned in 1917 and was left to deteriorate. The once beautiful old structure was finally demolished in 1960. All that remains is the automated fog bell and the foundation where the house once stood. (Vallejo Naval and Historical Museum.)

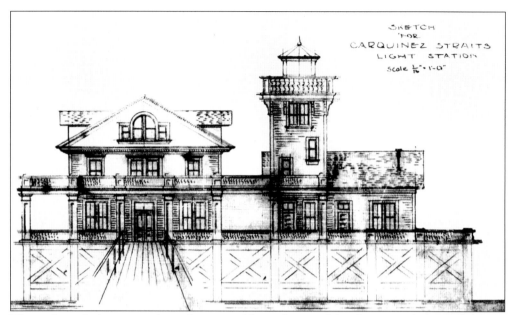

This architect's drawing outlines the original basic design of the Carquinez Strait Lighthouse. Although the design was modified, construction began in 1908 and was completed in 1910. (National Archives.)

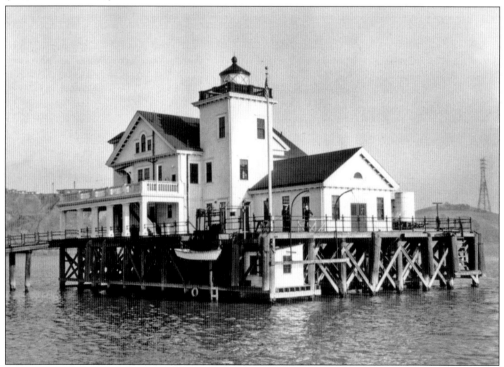

The lighthouse and keepers' quarters were one impressive structure built at the end of a 750-yard-long pier. The two-and-one-half story keepers' quarters had 28 rooms that housed three families. The three-story light tower and fog signal were attached to the main house. (Vallejo Naval and Historical Museum.)

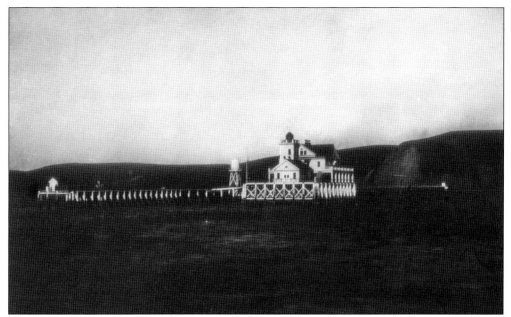

The Carquinez Strait Lighthouse began service on January 15, 1910. The 30-foot-tall tower housed a red, fourth-order, fixed Fresnel lens. The original fog signal was actually twin compressed-air sirens. (U.S. Coast Guard.)

The interior of the 28-room Victorian home at the Carquinez Strait Lighthouse was beautifully furnished. (U.S. Coast Guard.)

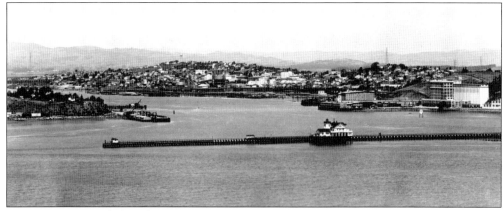

The pier was extended, and in 1951, a small building was added to house a new 375-mm beacon and an air diaphone horn. While the original lighthouse building remained in place, the U.S. Coast Guard built a new four-unit housing structure for the keepers on a nearby bluff. (Vallejo Naval and Historical Museum.)

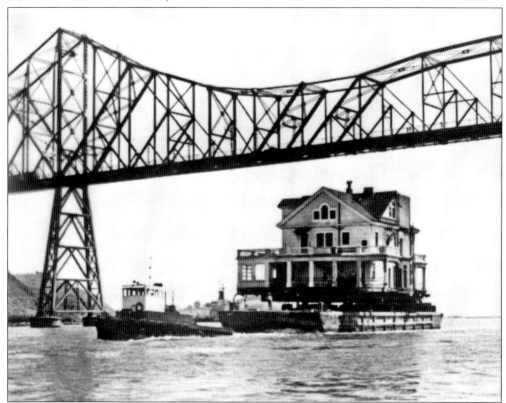

In 1955, Robert Hubert, a San Francisco building contractor, purchased the Carquinez Strait Lighthouse with plans to move it to nearby Glen Cove Marina. However, while preparing the structure for the move, Hubert fell and seriously injured himself. While recuperating, vandals broke into the lighthouse and smashed the Fresnel lens beyond repair, and the structure started to deteriorate. After his recuperation, three businessmen partnered with Hubert, and the move was back on track. In 1961, the lighthouse was loaded onto a barge and tugged to its new home. (Vallejo Naval and Historical Museum.)

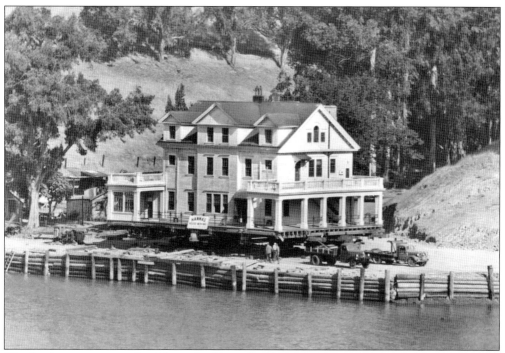

The final stage to move the 170-ton building was completed by truck. The building, minus the lantern structure and fog-signal building, was placed at Vallejo's Glen Cove, also known as Elliot Cove. (Vallejo Naval and Historical Museum.)

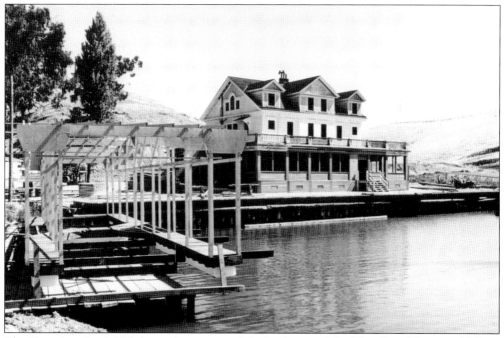

The Carquinez Strait Lighthouse is now part of the landscape of the Glen Cove Marina in Vallejo. Even without the three-story lantern tower, it is still an impressive building. (Vallejo Naval and Historical Museum.)

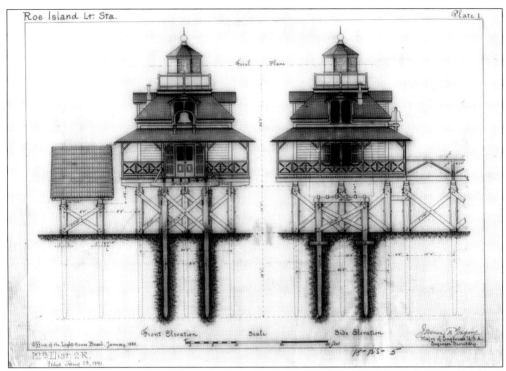

The original 1889 drawings for the Roe Island Lighthouse depict the building's design and pilings that would support the structure. The island, located 33 miles inland from the Golden Gate at the east end of Suisun Bay, is prone to flooding, so the structure had to be elevated. This station guided Sacramento River–bound ships safely through not only the ocean fog that extends this far inland, but also the thick low-lying tule fog of the valley. (National Archives.)

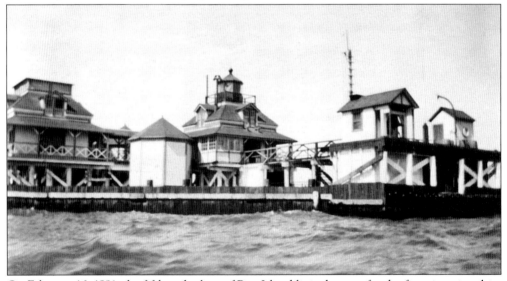

On February 16, 1891, the fifth-order lens of Roe Island lit its beacon for the first time, its white flash shinning every 2.5 seconds. The 800-pound, iron, fog bell was housed in a small structure at one end of the T-shaped pier. The bell tolled one stroke every 10 seconds. The bell's counter weight tower can be seen above the bell house. (U.S. Coast Guard.)

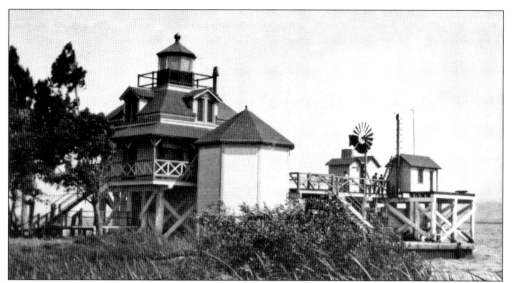

The octagon-shaped water tower collected rainwater from the roof. The windmill not only provided power, but also pumped water to a tank on the roof of the outhouse, one of the small structures seen behind the windmill, thus the facilities had running water, rather unusual for a lighthouse station. The other small building next to the outhouse was the oil room where the lantern fuel was housed. (U.S. Coast Guard.)

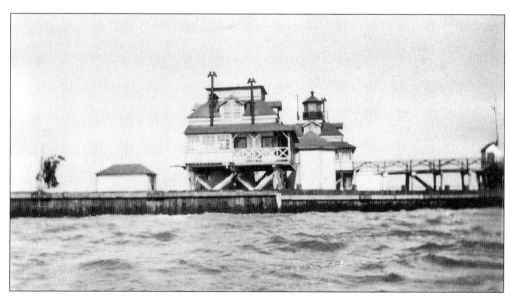

In the 1900s, a second structure was added to the Roe Island station. It mirrored the lighthouse building, except it did not have the lantern room at the top, only a widow's walk. (U.S. Coast Guard.)

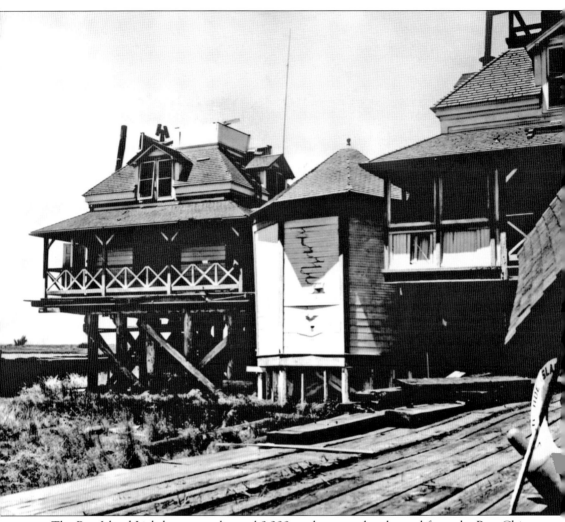

The Roe Island Lighthouse was located 3,000 yards across the channel from the Port Chicago Naval Magazine. At about 10:20 p.m. on the night of July 17, 1944, two ships, the *Quinault Victory* and the *E. A. Bryan,* were being loaded with thousands of tons of ammunition when an enormous explosion and blinding flash filled the night's sky. The explosion killed more than 300 men, destroyed both ships and two U.S. Coast Guard ships, and demolished most of the train that carried the explosives. The explosion all but destroyed most of the structures at the lighthouse. The keeper, Erven Scott, and his wife, Bernice, along with the assistant keeper, did what they could to keep the lighthouse functioning, but the station was closed the following year. Roe Island is the only lighthouse in California that was decommissioned due to war-related damage. (U.S. Coast Guard.)

The U.S. Lighthouse Society was an invaluable resource for this book and a must-join for all lighthouse enthusiasts. Membership in the nonprofit society includes a subscription to *The Keeper's Log*, a quarterly publication that provides information about lighthouses from cover to cover, including historic photography, maps and drawings, as well as current notices about lighthouse events. To learn more, visit the U.S. Lighthouse Society's Web site at www.uslhs.org.

ACROSS AMERICA, PEOPLE ARE DISCOVERING
SOMETHING WONDERFUL. *THEIR HERITAGE.*

Arcadia Publishing is the leading local history publisher in the United States. With more than 4,000 titles in print and hundreds of new titles released every year, Arcadia has extensive specialized experience chronicling the history of communities and celebrating America's hidden stories, bringing to life the people, places, and events from the past. To discover the history of other communities across the nation, please visit:

www.arcadiapublishing.com

Customized search tools allow you to find regional history books about the town where you grew up, the cities where your friends and family live, the town where your parents met, or even that retirement spot you've been dreaming about.